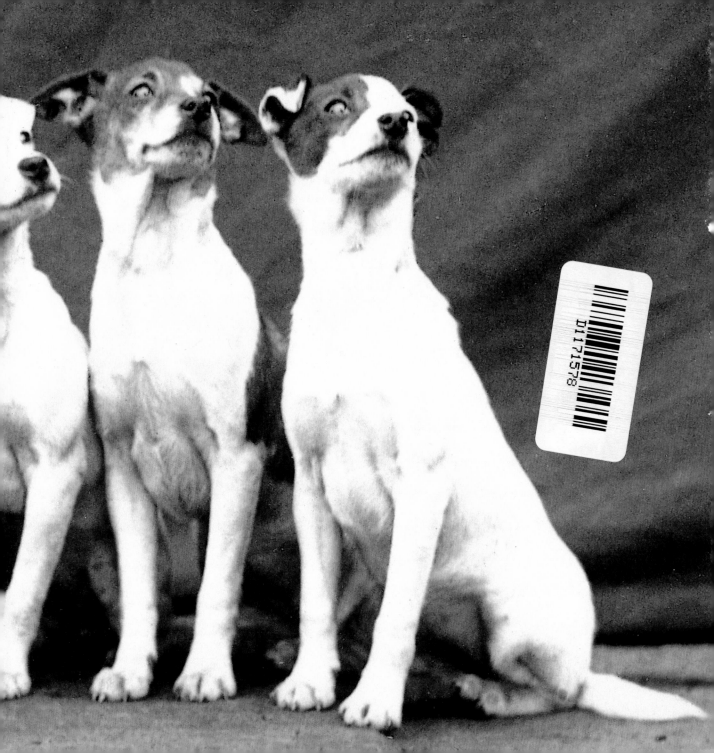

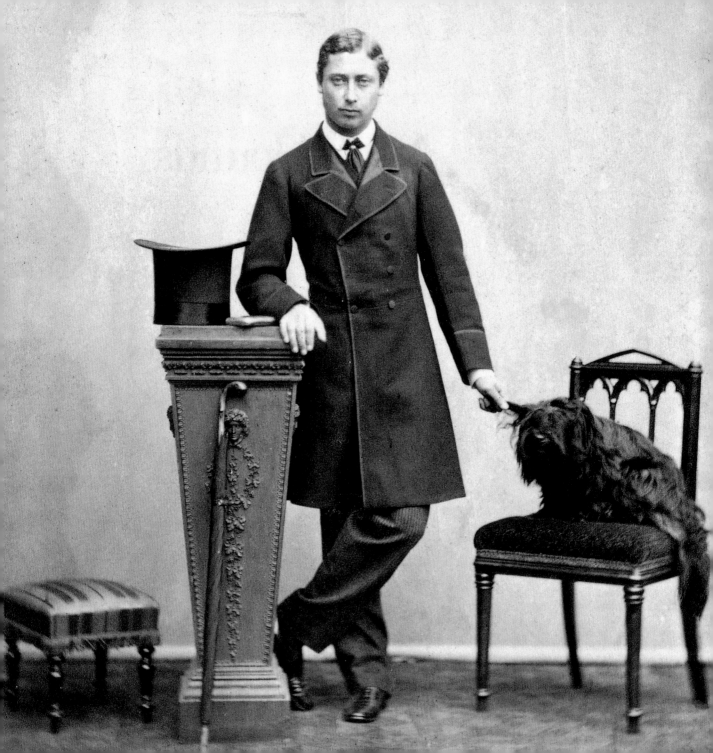

Sophie Gordon

Noble Hounds and Dear Companions

The Royal Photograph Collection

ROYAL COLLECTION PUBLICATIONS

Published by Royal Collection Enterprises Ltd
St James's Palace, London SW1A 1JR

For a complete catalogue of current publications,
please write to the address above, or visit our
website on www.royalcollection.org.uk

157602

ISBN 978 1 902163 857

British Library Cataloguing in Publication Data:
A catalogue record for this book is available from
the British Library.

Designed by Adam Brown, 01.02
Production management by Debbie Wayment
Typeset in Bauer Bodoni
Printed on Symbol Tatami White,
 Fedrigoni Cartiere Spa, Verona
Printed and bound by Studio Fasoli, Verona

Three of Queen Victoria's
dogs (a dachshund,
a fox terrier and a pug)
and a very small cat,
painted by Charles Burton
Barber in 1885.

Contents

Overleaf: Four dogs, one groom, one pony and seven of Queen Victoria's grandchildren play in the gardens at Osborne, on the Isle of Wight, August 1891. From left to right: Princess Margaret and Princess Patricia of Connaught; Prince Waldemar of Prussia (grandson of Victoria, Princess Royal); Prince Arthur of Connaught; and Prince Leopold, Prince Alexander and Princess Victoria Eugénie of Battenberg (children of Princess Beatrice).

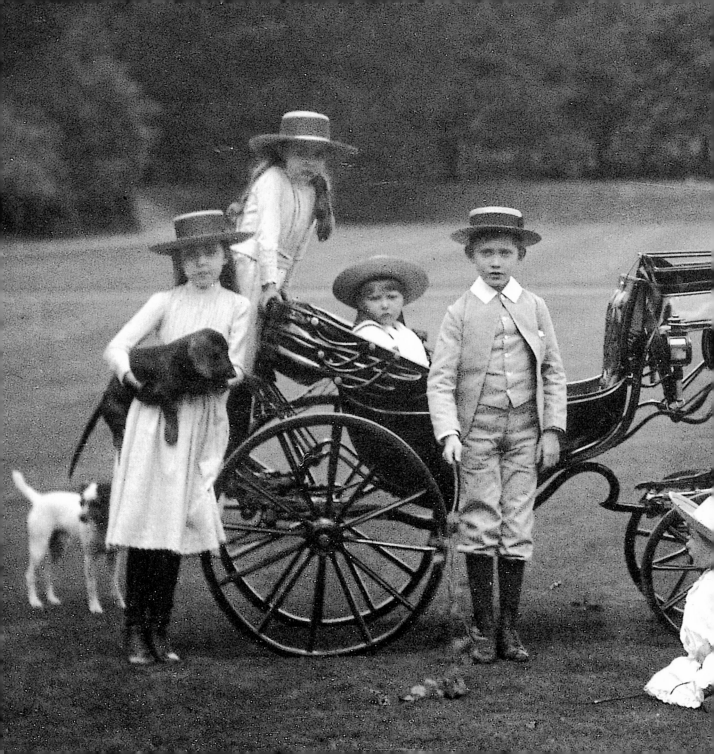

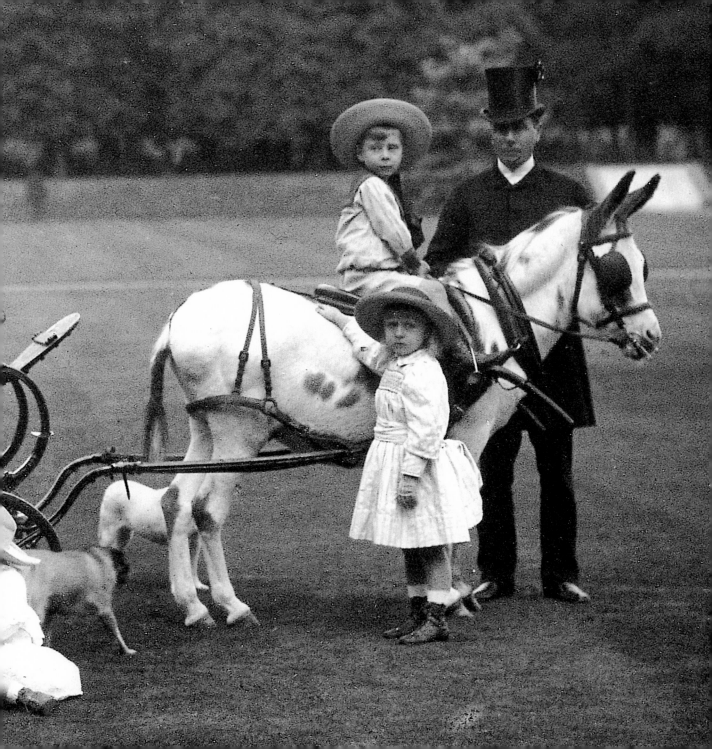

Introduction

Dogs have always played an important role in the public and private lives of the Royal Family. From the corgi, which today has almost become a symbol of the House of Windsor, to the dachshund that was popularised in Britain by Prince Albert in the 1840s, dogs of many different types of breeds have been acquired by successive generations, by purchase or by gift. Working dogs were kept not only for the service they provided, but also for the companionship and loyalty they offered unquestioningly. Other more exotic breeds were received from China, Russia and India, as diplomatic gifts, curiosities and symbols of the relationships between Britain and other countries.

A large number of paintings and drawings in the Royal Collection show dogs owned by kings and queens over the centuries. The Cavalier King Charles Spaniel for example, popular during the reign of Charles I (r.1625–49), appears in several paintings produced by the court painter Sir Anthony Van Dyck. Two hundred years later, the first painting produced for Queen Victoria by Sir Edwin Landseer was of her pet dog Dash, also a Cavalier King Charles Spaniel. Landseer included several of the Queen's dogs in another painting, *Windsor Castle in Modern Times* (1840–43) which shows Prince Albert and the Queen surrounded by four of their pet dogs. The Queen also engaged Landseer's pupil, Friedrich Keyl, to provide watercolours and sketches of a number of animals in her household. Several of Keyl's dog portraits are included in the album Queen Victoria compiled, *Portraits of Dogs etc. 1847–76*. But it was through the new medium of photography that the full range of the royal family's animals – not

Above: Dash was given to Princess (later Queen) Victoria in 1833. Landseer's portrait of the dog was a birthday present from the Princess's mother, the Duchess of Kent, in 1836.

Right: Two Cavalier King Charles Spaniels appear in Van Dyck's portrait *The Three Eldest Children of Charles I*, painted in 1635.

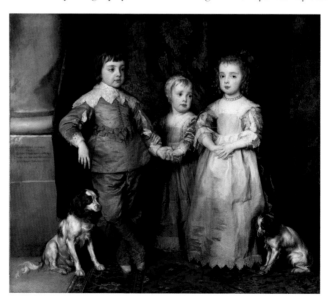

Landseer's *Windsor Castle in Modern Times*, painted in the early years of Queen Victoria's marriage to Prince Albert, shows the infant Princess Royal and four of the royal dogs (Eos, Islay, Cairnach and Dandie Dinmont) in the Green Drawing Room at Windsor.

A kennel master sits with three greyhounds, Beauty, Swan and Mishka, in this photograph from a series taken in the Royal Kennels, Windsor, in 1865 by William Bambridge. Swan (d.1867) was given to Queen Victoria by Dr Hanley of the 1st Life Guards regiment in February 1859. Mishka was the daughter of Swan, born on 30 April 1861 (and was later to be the mother of Helios; see overleaf and page 15).

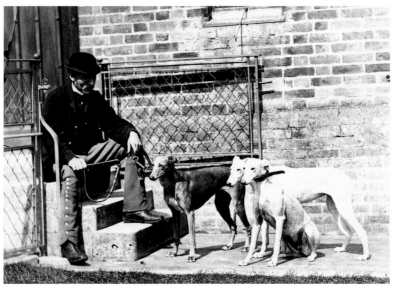

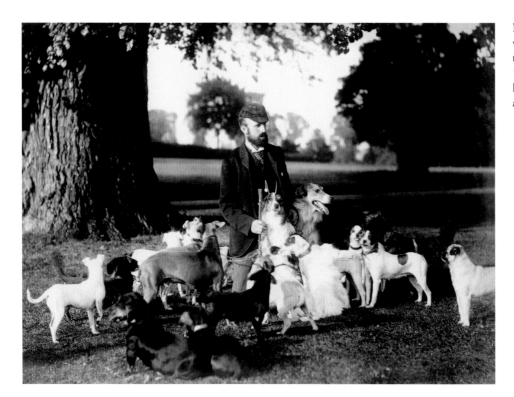

Mr Hill, the kennel master, with some of the dogs from the Windsor kennels in 1891. The group includes Borzois, pugs, fox terriers, a greyhound and dachshunds.

The front cover of the album containing portraits of dogs in the kennels at Windsor, taken by photographer William Bambridge in 1865. The greyhound on the cover is Helios.

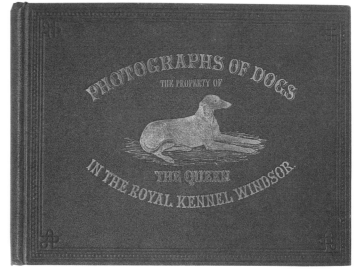

PHOTOGRAPHS OF DOGS
THE PROPERTY OF
THE QUEEN
IN THE ROYAL KENNEL WINDSOR.

just the dogs – was first documented in its entirety. The camera was ideal for allowing each individual animal, whether a dog, cat, horse, pig, or even an elk in Windsor Great Park, to become a subject in its own right, rather than just a small face in the corner of a large oil portrait of its master or mistress. The extensive photographic recording of the animals indicates also the importance that they held in the minds of their royal owners. Although in the 19th century photography was relatively much cheaper than commissioning a painting, and of course far less time-consuming, it was still a considerable expense to ask a photographer to provide a series of photographs of the dogs in the Royal Kennels. In 1854, for example, the total cost of photographing the dogs at Windsor, including making the prints, mounting and captioning them in an album came to £25 19s, the equivalent of around £1,650 today. That particular photographic session took the Windsor-based photographer William Bambridge thirty days to complete, but he created a fine and long-lasting record which survives today in the Royal Collection and which set a pattern for systematically photographing the kennel dogs at Windsor over the following decades.

Professional photographers continued into the 20th century to record royal dogs, sometimes alongside their royal owners. The selection of photographs included in this book, all drawn from the Royal Photograph Collection, shows how dogs have played an important role in the life of the Royal Family, as well as highlighting how canine fashions have been led by their choices, and how animal welfare in general has benefited from their love of dogs.

Left: This wonderful silver-gilt centrepiece includes miniature figures of the same four dogs that had appeared in Landseer's painting: Eos, Islay, Cairnach and Dandie Dinmont. Made by Garrards – to the designs of Prince Albert – in 1842–3, it was exhibited at the Great Exhibition in 1851.

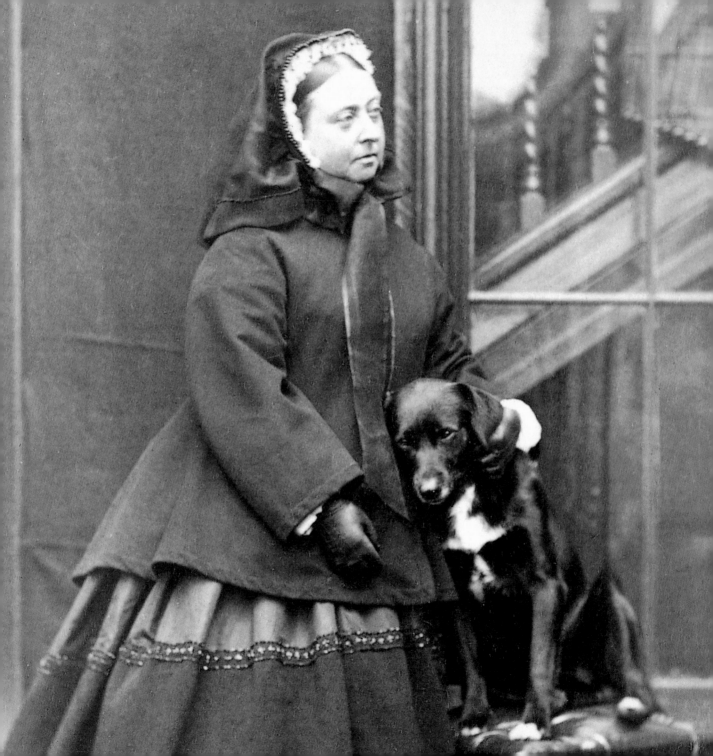

Queen Victoria and Prince Albert and their family

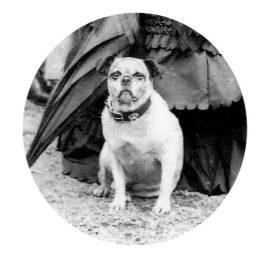

One of several images showing Queen Victoria (1819–1901) with her collie Sharp in 1866. These were sold to the general public as cartes-de-visite.

Prince Albert's favourite greyhound, Eos, accompanied his master from Germany to England in 1840. She died four years later, having been the Prince's companion for over ten years. This portrait of Eos was a Christmas present from the Queen to the Prince in 1841. Landseer has portrayed the elegant hound, steadfastly loyal to her master, whose cane, hat and gloves await his arrival.

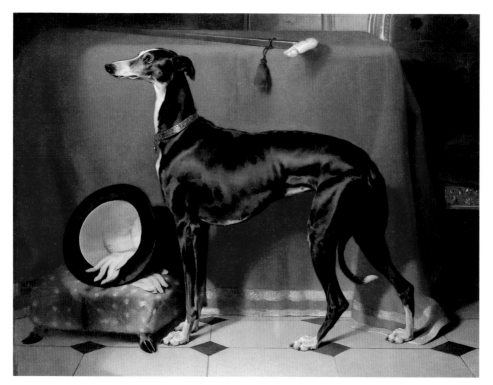

Laura was a granddaughter of Eos and entered the Royal Kennels in 1847. Swan (daughter of Skip and Blucher) was born at Windsor in 1845 and died in 1856. The artist, F.W. Keyl, was Landseer's only pupil.

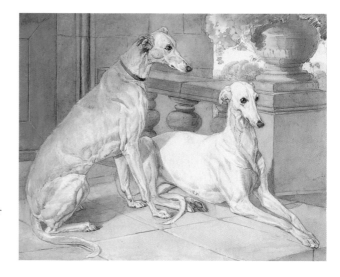

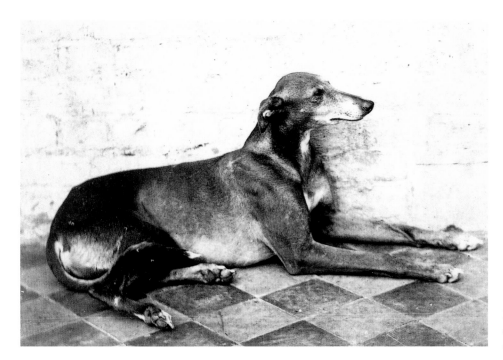

Helios the greyhound was the
son of Mishka and was born
on 1 June 1864.

Giddy, a later greyhound,
with an elegant polka-dot
coat, was born in May 1871.
Giddy was the daughter of
'Master McGrath' (who
belonged to Lord Lurgan)
and 'Specie' (who belonged to
James Galwey). She was
given to Queen Victoria by
Lord Lurgan in March 1873
and was photographed
soon after.

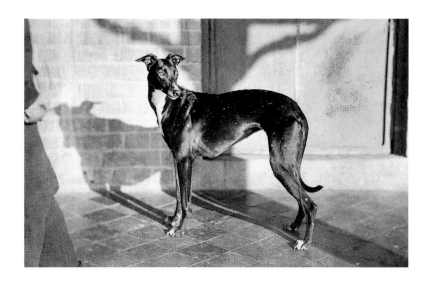

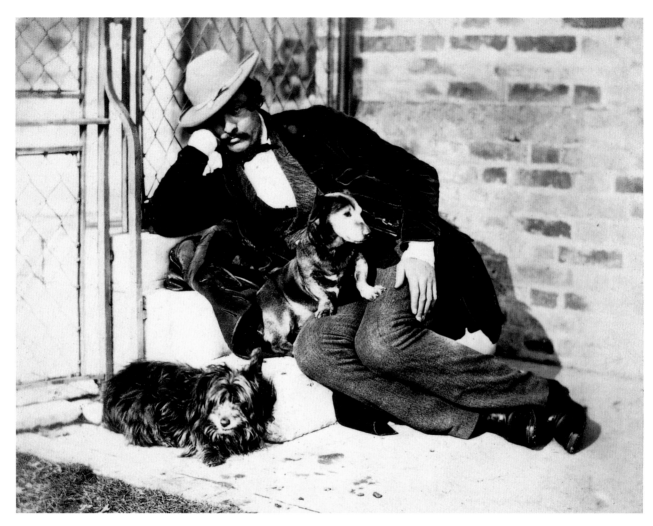

Cowley, one of Victoria and
Albert's *jägers*, or outdoor
servants, sits with Dandie – an
early Dandie Dinmont terrier –
and Deckel, the dachshund that
Queen Victoria brought back
from Coburg in 1845. Deckel died
in 1859, four years after this
photograph was taken.

Boy, an early favourite dachshund, sits with John Macdonald. Boy was born at the Windsor kennels in July 1857. His parents were Trump and Sybilla. John Macdonald was first engaged as a *jäger* at Balmoral, but came to Windsor in 1848 to be in charge of the kennels. He died of consumption in 1860, the year this image was taken.

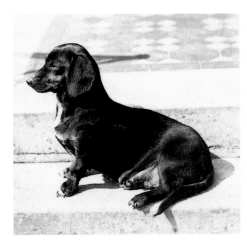

Berghina, described as a 'German dachs dog'. Berghina was sent over from Germany in September 1865, a gift from Ernest II, Duke of Saxe-Coburg and Gotha, the elder brother of Prince Albert.

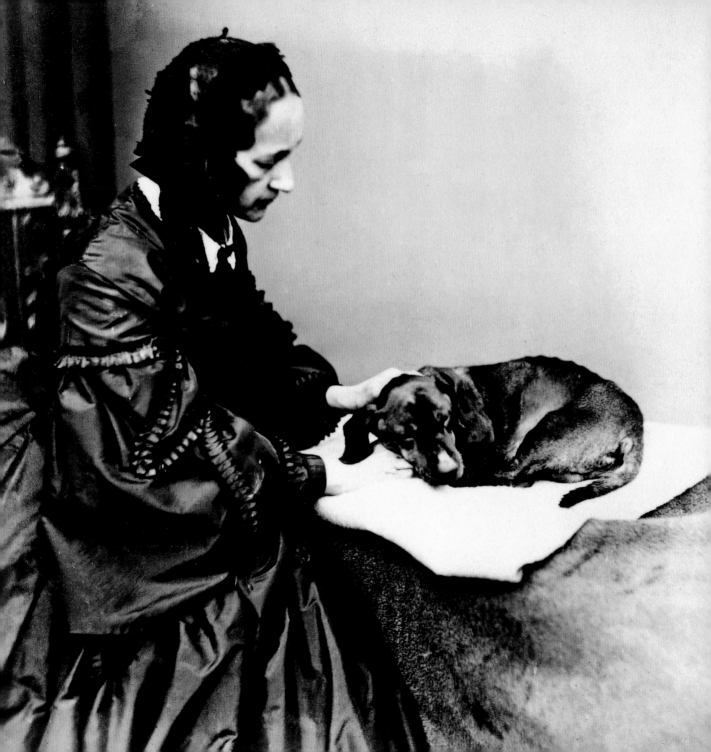

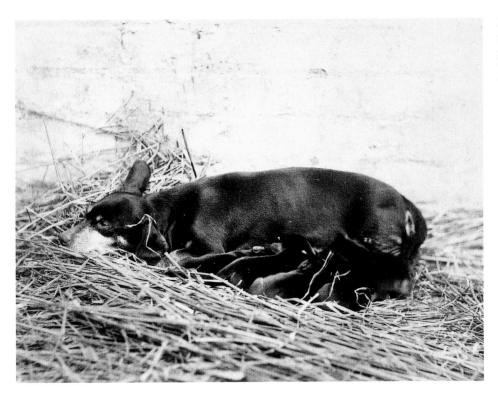

Zerline and her puppies in the Windsor kennels, photographed by Bambridge. The puppies were born on 17 August 1865.

Boy, photographed on 9 February 1863 being tended by Mrs Lawley, the housekeeper at Frogmore, a few days before his death. Boy died on 20 February 1863. Queen Victoria noted in her journal 'gt. sorrow to lose dear little Boy…'

The Queen's favourite dachshund, Waldman VI, was brought over from Baden in April 1872.

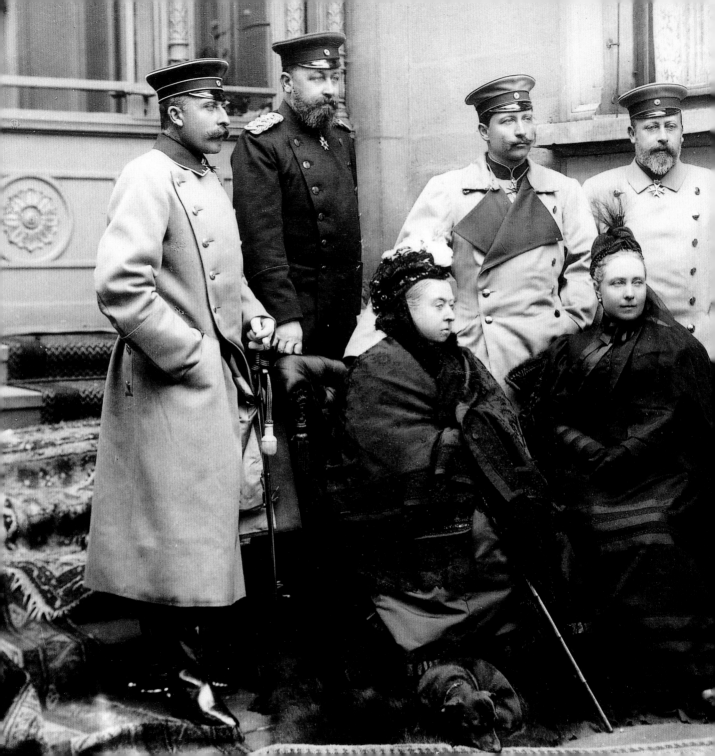

Left: Queen Victoria, visiting Coburg in 1894, sits with her eldest child, Victoria, the Dowager Empress Frederick of Germany (1840–1901), while her three eldest sons stand behind her, along with the Empress Frederick's son, Kaiser Wilhelm II of Germany (1859–1941). A small dachshund sleeps at the feet of the Queen. Standing, from left to right: Prince Arthur, Duke of Connaught; Prince Alfred, Duke of Edinburgh and Saxe-Coburg and Gotha; Kaiser Wilhelm II of Germany; and Albert Edward, Prince of Wales (later King Edward VII).

Below: Princess Victoria of Prussia with her dachshund in 1892. Princess Victoria (1866–1929) was the second daughter of Emperor Frederick III of Germany and the Princess Royal, the eldest daughter of Queen Victoria.

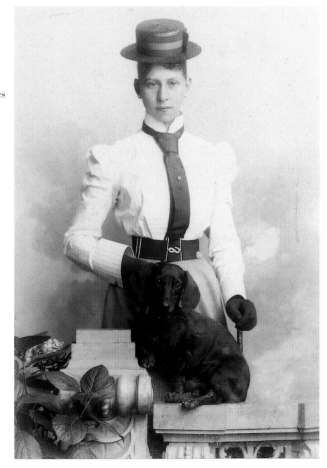

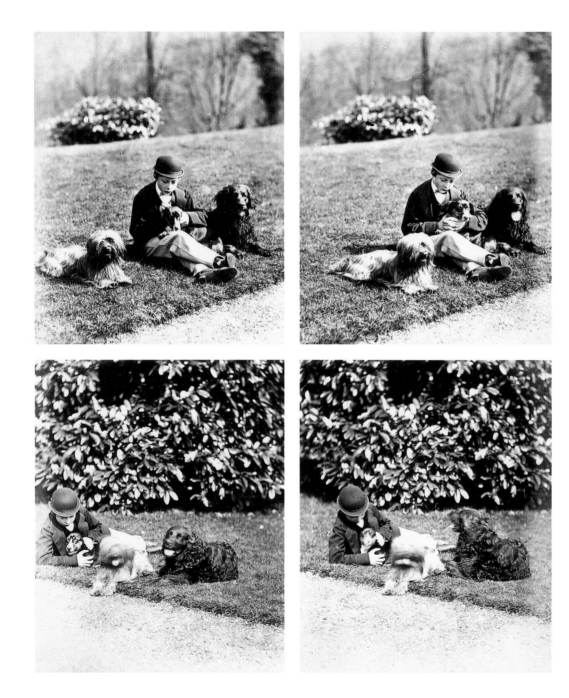

Left: Queen Victoria and
Prince Albert's fourth son,
Prince Leopold, with Corran
the terrier, Waldman the
dachshund and Comet the
collie in 1865. Corran
belonged to Prince Leopold's
brother Prince Alfred, the
photographer of these images.

Right: Princess Helena
(1846–1923) watches over
a small terrier. The Princess
was the fifth child and third
daughter of Queen Victoria
and Prince Albert.

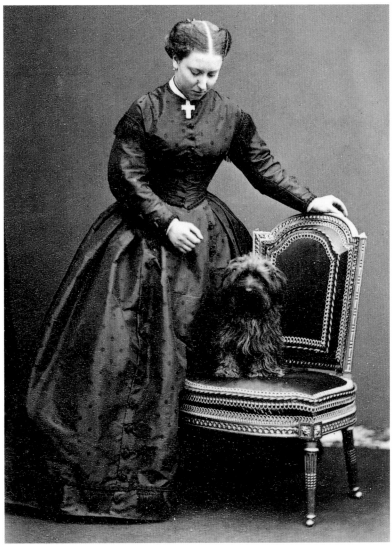

Topsy, described as a 'Scotch
terrier', was born in June
1865, the year this
photograph was taken.

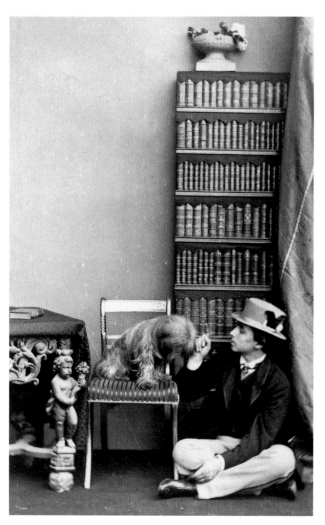
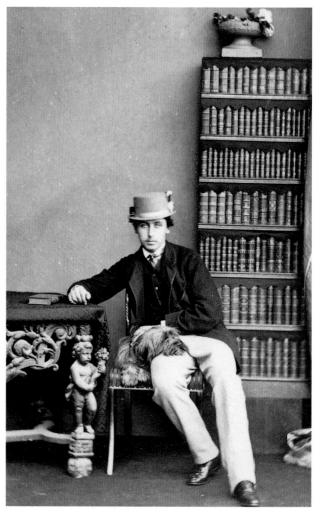

Prince Alfred (1844–1900),
the second son of Queen
Victoria, took these four
self-portraits in 1864. The
dog appears to be Corran,
one of the perennially
popular Scotch terriers
owned by Queen Victoria
and her children.

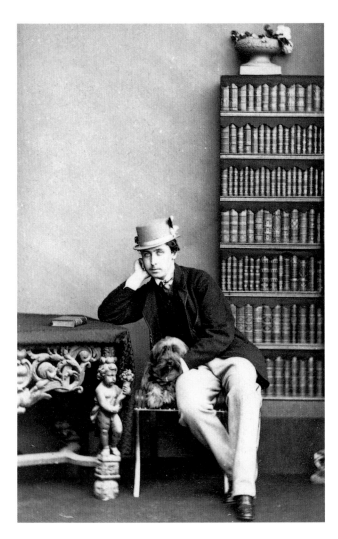
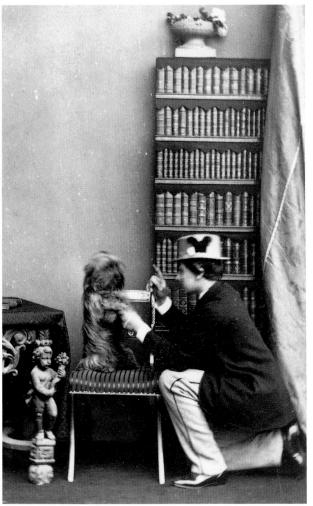

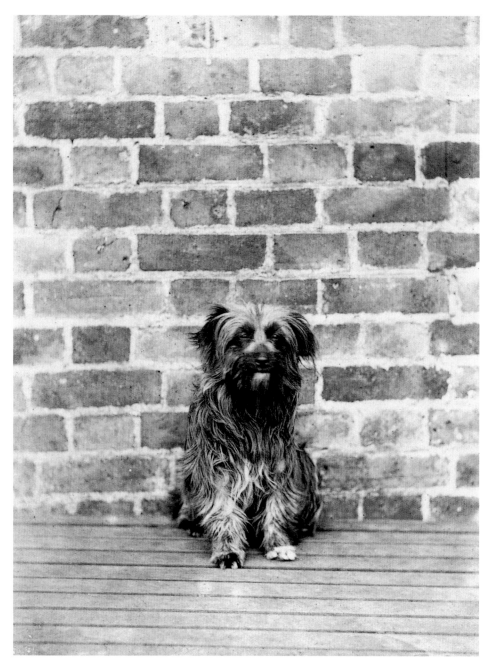

Left: Princess, the daughter of Ferish and the mother of Brenda and Minna, was born at Windsor on 10 April 1868.

Right: Minna was the daughter of Corran (Prince Alfred's dog) and Princess.

Far right: Brenda, born in February 1869, was also the daughter of Corran and Princess. Brenda was given to Prince Alfred, Duke of Edinburgh, in 1873.

Right: Dot was born in July 1872. She was the daughter of Minna and Princie.

Far right: Topsy was the brother of Dot, part of the same litter born in July 1872.

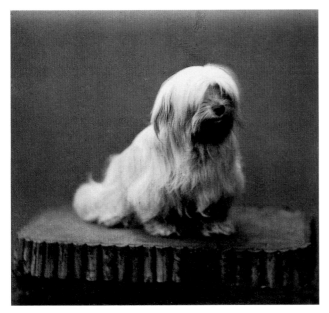
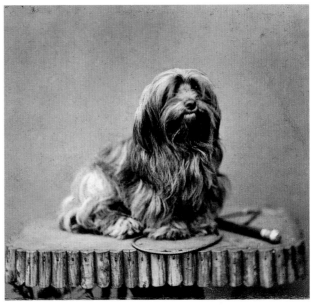
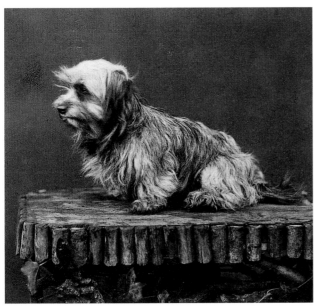
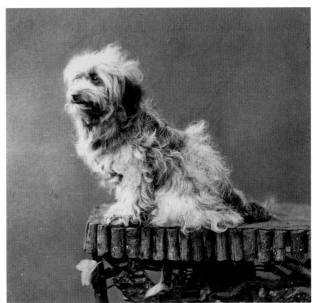

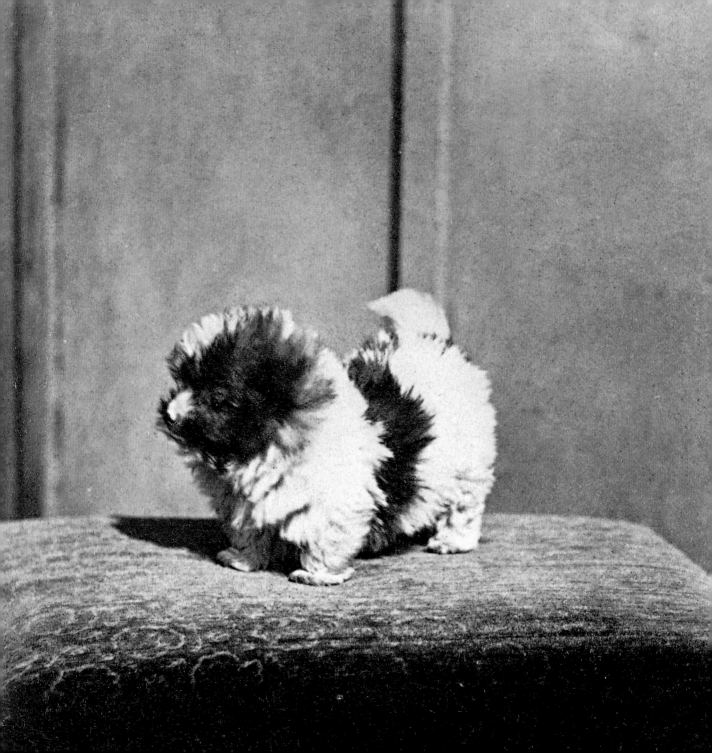

Left: Tiney, a Scotch terrier, is described in the photograph album as 'one of Queen Victoria's favourite dogs'. He was born on 10 February 1866, the son of Topsy and Princie.

Right: Dandie, another Scotch terrier, bought in June 1866.

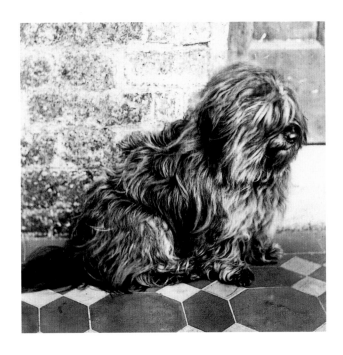

Dandie Dinmont, a 10-year-old Scotch terrier. At the time this photograph was taken (1857) the Dandie Dinmont breed was not as well defined as it is today. The breed was named after a character in Sir Walter Scott's novel *Guy Mannering* (1814), who was described as owning this type of terrier.

Prince Wilhelm of Prussia playing with a terrier in 1864. Prince Wilhelm (1859–1941) was the eldest son of the Princess Royal, Queen Victoria's eldest daughter. He became Emperor of Germany in 1888, following the death of his father, Frederick III. He is seen (as Kaiser Wilhelm II) standing behind his grandmother and mother on page 20.

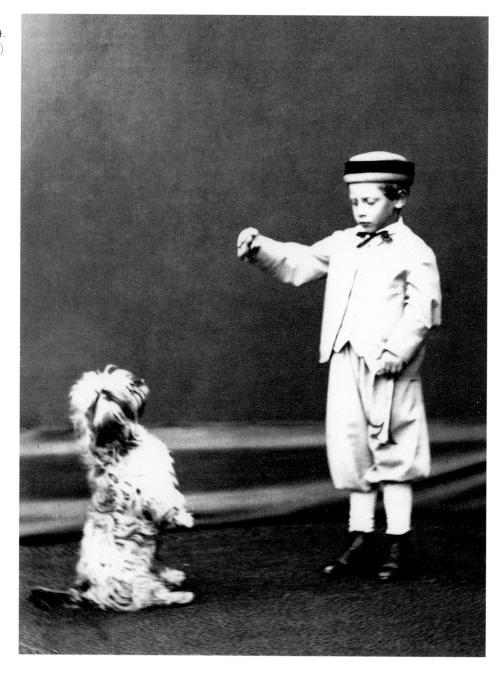

Princess Alice of Albany (1883–1981) stands next to Skippy, the dog acquired from Battersea Dogs Home by her father, Prince Leopold.

Looty, said to be the first Pekingese in Britain, was brought back from China following the Second Opium War, and given to Queen Victoria in April 1861. She was painted by F.W. Keyl in the same year (right) and photographed by Bambridge in 1865 (left). Looty survived in the Windsor kennels until 1872.

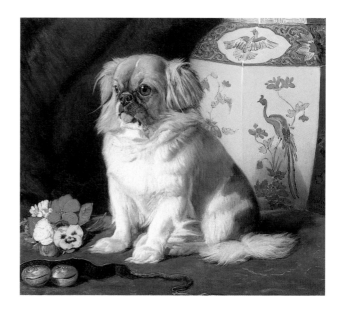

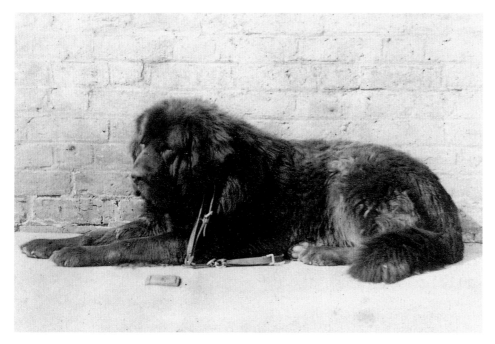

Bout was always described as a 'Cashmere dog', but is in fact a Tibetan Mastiff. He was given to Queen Victoria by Lord Hardinge (Viscount Hardinge of Lahore) in 1847. Hardinge was Governor-General of India between 1844 and 1848. Bout lived in the kennels at Windsor until his death in June 1856, two years after this photograph was taken.

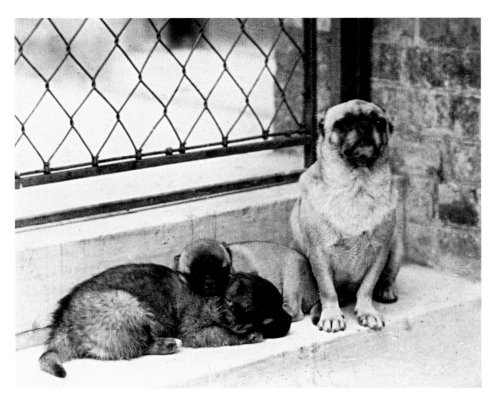

Left: A proud-looking Venus with her two puppies. Venus arrived in the kennels at Windsor in 1853 and had her puppies the following year. She died on 23 February 1860.

Right: A group of pugs. Fermac was born at the Windsor kennels in June 1862; Mops and Mishka (brother and sister) were born in August 1866 and given to the Queen by a Mr Tyrrell.

Lass was born in May 1870 and died in February 1873, the year after she was photographed. She was given to Queen Victoria by a Mr Overton.

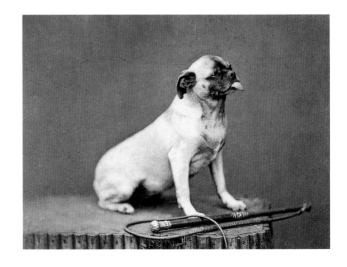

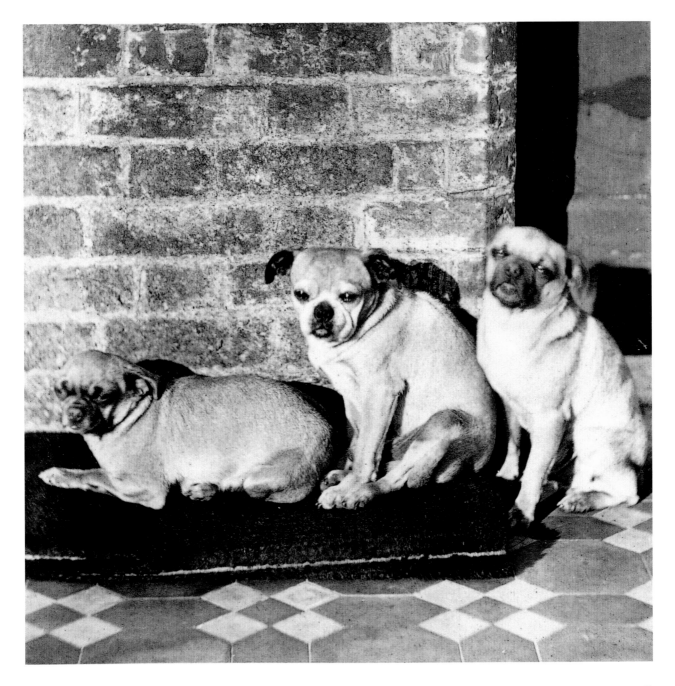

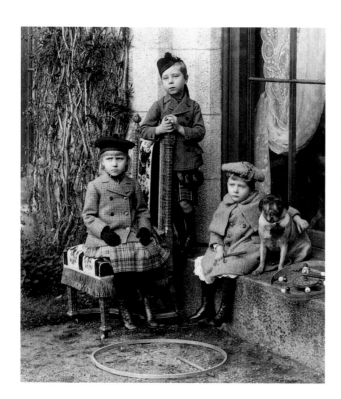

The three eldest children of Princess Beatrice and Prince Henry of Battenberg with a pug, at Balmoral in September 1891. From left to right: Princess Victoria Eugénie (1887–1969), Prince Alexander (1886–1960) and Prince Leopold (1889–1922). Princess Victoria, known as Ena, subsequently married King Alfonso XIII of Spain.

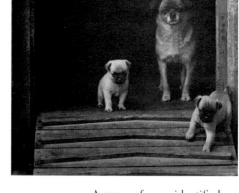

A group of pugs, identified as 'Ayah's daughter and her pups', carefully leave their kennel.

Prince Alexander of Battenberg with Basco. Prince Alexander was the eldest child of Princess Beatrice and Prince Henry of Battenberg. In 1917 he became the Marquess of Carisbrooke.

Queen Victoria sits with members of her family and one of her pugs at Balmoral in 1887. From left to right: Prince Albert Victor, Duke of Clarence (1864–92), the eldest son of the Prince and Princess of Wales; Princess Alix of Hesse (1872–1918), the Queen's granddaughter and future Tsarina of Russia; Princess Beatrice (1857–1944), the Queen's youngest daughter; and Princess Irene of Hesse (1866–1953), sister of Princess Alix. Princess Alix is said to have refused a proposal of marriage from Prince Albert Victor before subsequently marrying Tsar Nicholas II of Russia.

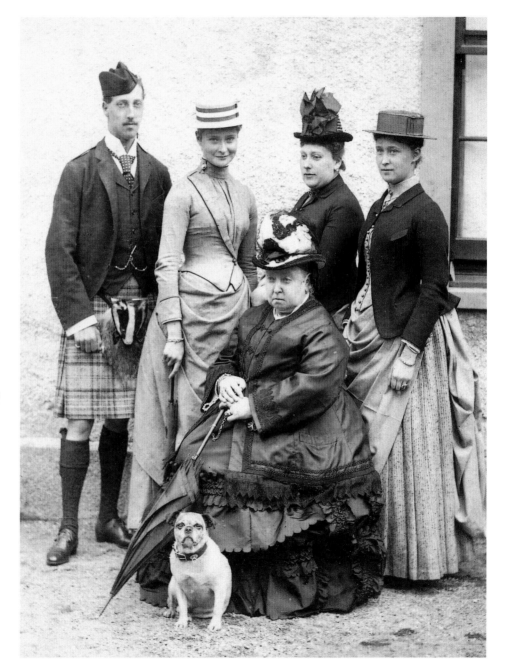

The Queen's pony Sultan with her servant Andrew Thomson at Balmoral in 1870. The dogs, from left to right, are Sharp, Friskie (who belonged to Princess Louise), Dacko and Prince Alfred's terrier, Corran.

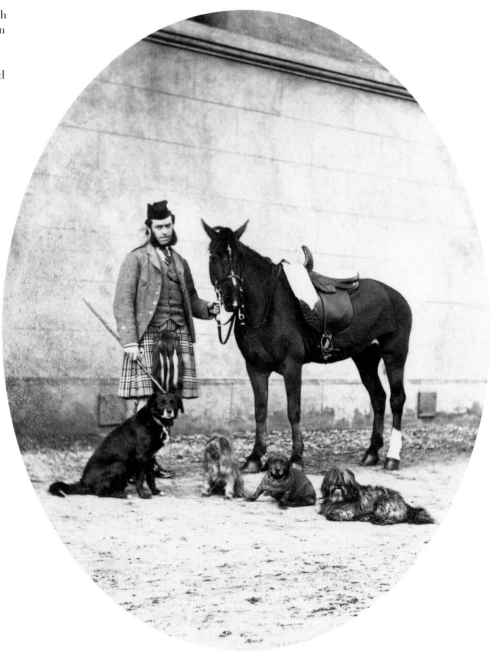

A group of four of the Queen's favourite dogs, taken at Windsor Castle in 1879. From left to right: Noble III the collie, who is identifiable by the white T-shape on his chest; Waldmann VI the dachshund; Wat, the fox terrier (who belonged to Princess Beatrice) and Fern, another collie.

A portrait of Noble III, one of
Queen Victoria's favourite dogs,
who was given to the Queen
in May 1872. He is described
in the photograph album as
a collie of the Cheviot breed.

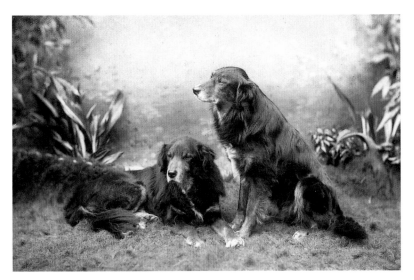

'Old Noble' and 'Young Noble', photographed together in 1886. Noble III, who died in 1887, was the grandfather of Noble V.

A collie puppy, Bess, born on 25 September 1875. She was the daughter of Noble III and Nellie.

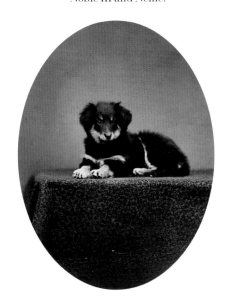

The descendants of Noble III: Regina, a gift from the Duchess of Roxburghe, and her puppies, great-grandchildren of Noble, photographed in the early 1880s.

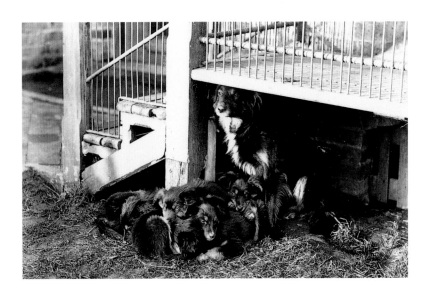

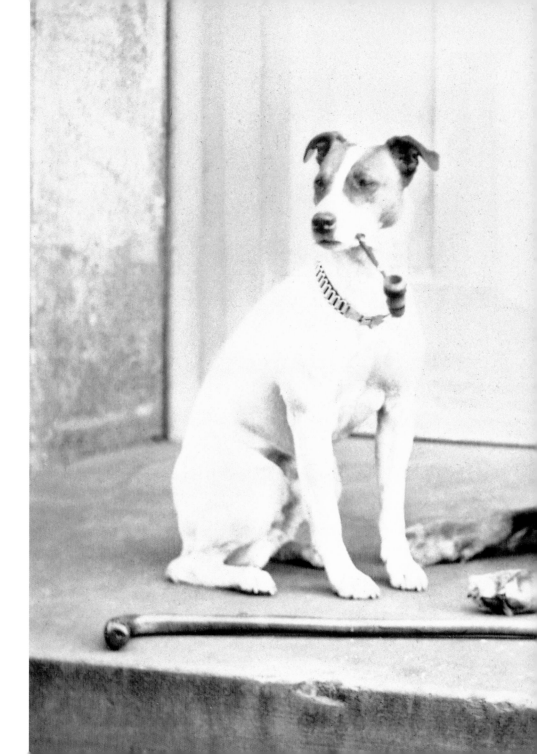

Spot, a fox terrier, relaxing
with Noble III in 1883.

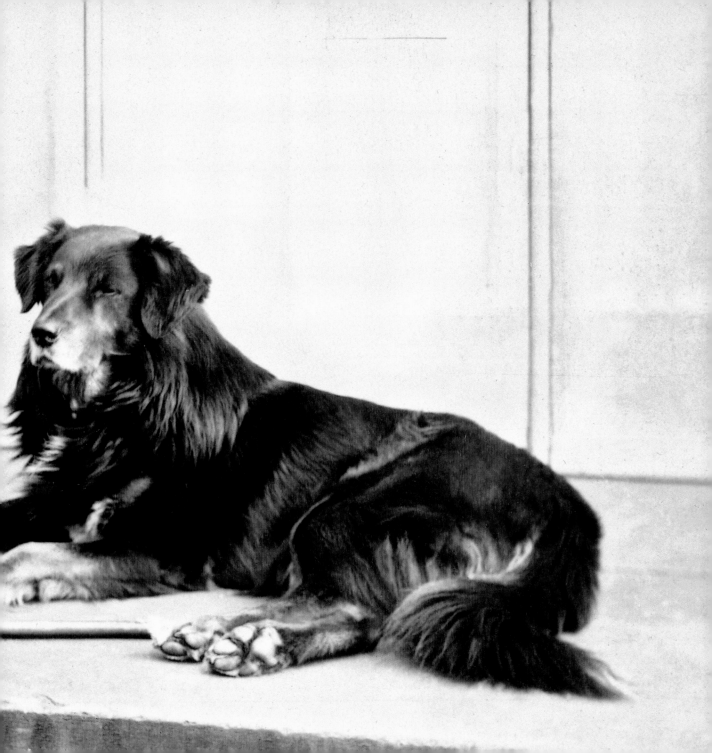

Turi the Pomeranian and Roy the collie, photographed in 1896. Roy was the second of the Queen's collies to bear that name.

Below: Nannie, a white Border Collie, was a gift to the Queen from the Earl of Haddington on 29 May 1885. Nannie was 9 months old when she arrived at Windsor; she died in 1889.

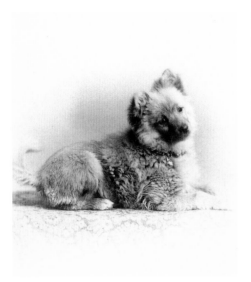

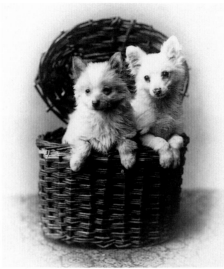

Far left: Marco the Pomeranian as a puppy. The Queen acquired Marco – her first Pomeranian – in Italy in 1888. The breed quickly became a favourite.

Left: Two more of Queen Victoria's beloved Pomeranians, Lina and Beppo. Beppo was one of the dogs shown at Crufts in 1891.

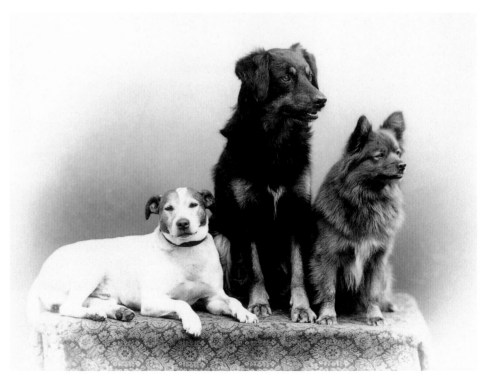

Spot, Roy and Marco, in June 1891.

William Brown, personal servant to Queen Victoria at Balmoral, sits with Marco, Turi and Roy. Despite their obvious differences, both Marco and Turi were described as Pomeranians.

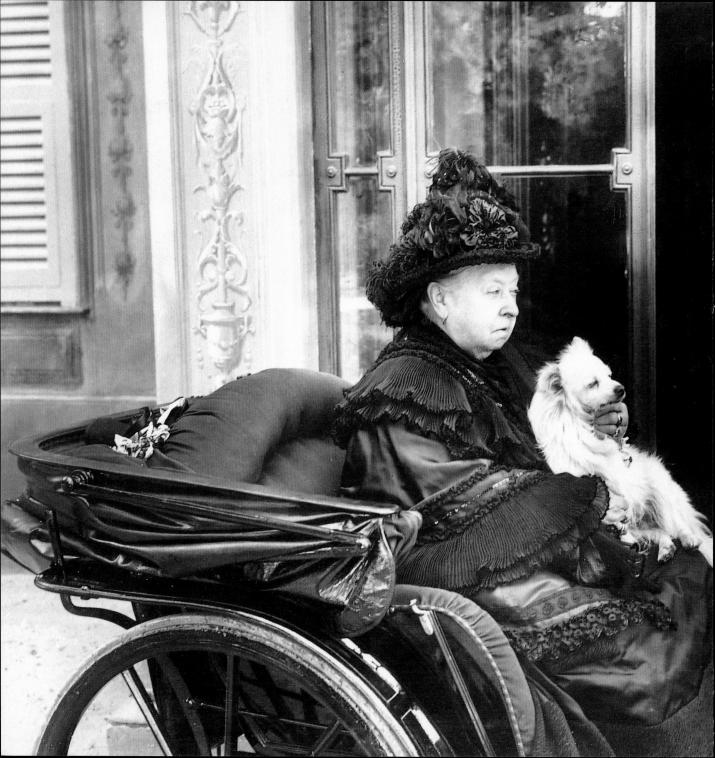

Left: Queen Victoria holds her last Pomeranian, Turi, as she goes out for a drive in her carriage. Turi was acquired by the Queen in 1893.

These two dogs, Biche and Daine, were the puppies of the two favourite dogs of Queen Victoria's son-in-law, Emperor Frederick III of Germany. They were given to Queen Victoria in July 1888, only a month after the Emperor's death. It is possible that they are Weimaraners, although the breed has changed considerably in appearance since the late 19th century.

Below: Queen Victoria with family members and the fox terriers Spot, Gay Girl and Wat at Balmoral, 21 October 1882. The group includes, from left to right, Louis IV, Grand Duke of Hesse (Princess Alice's widower), Princess Beatrice, Queen Victoria, Princess Alix and Prince Ernest Louis of Hesse (children of Princess Alice), and the Duchess of Connaught (married to Prince Arthur) and her daughter Princess Margaret of Connaught.

Princess Alexandra of Edinburgh (1878–1942) with her collie. Princess Alexandra was the fourth child of Prince Alfred, Duke of Edinburgh, and Grand Duchess Marie of Russia. When her father inherited the title of Duke of Saxe-Coburg and Gotha in 1893, she moved with her family to Germany, where she lived for the rest of her life.

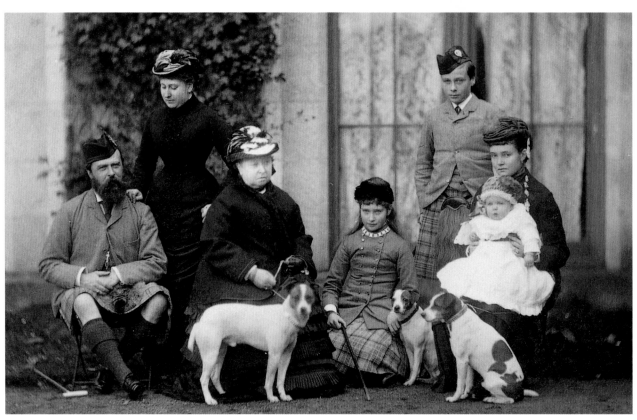

Left: The two youngest children of Prince Alfred, Duke of Edinburgh, pose with their collie, in Coburg in 1886. Princess Alexandra is seated on the left, and Princess Beatrice (1884–1966) is standing.

Prince Alfred, Duke of Edinburgh
and Saxe-Coburg and Gotha, with
his wife Marie, family and friends
in 1890. Prince Alfred was the
second son of Queen Victoria and
Prince Albert, inheriting the title
of Duke of Saxe-Coburg and
Gotha through his father. Left to
right, standing: second from left,
Prince Alfred of Saxe-Coburg and
Gotha; fourth from left, Princess
Alexandra of Saxe-Coburg and
Gotha; fifth from left, Prince
Ernest of Hohenlohe-
Langenburg. Seated: Princess
Beatrice of Saxe-Coburg and
Gotha (holding a terrier); Alfred,
Duke of Edinburgh and Saxe-
Coburg and Gotha, and Marie,
Duchess of Saxe-Coburg and
Gotha; Grand Duke Paul
Alexandrovitch of Russia.
The dog at the Duchess's feet
appears to be related to today's
breed of French bulldog.

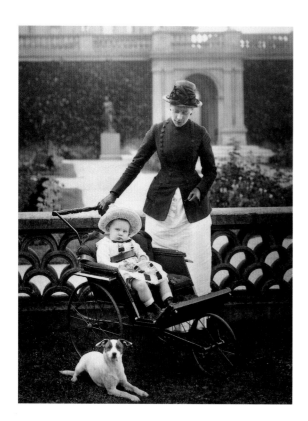

Left: Prince Arthur of Connaught (1883–1938), the son of Prince Arthur, Duke of Connaught, is taken out in the grounds of Osborne House in August 1884. He and his nurse, Susan Chapman, are accompanied by a small fox terrier.

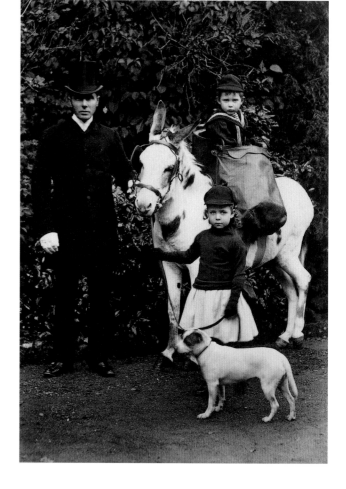

Right: Princess Margaret of Connaught (1882–1920) and her brother Prince Arthur (seated in a basket on the donkey's back) are taken out for a donkey ride by Beaumont the groom.

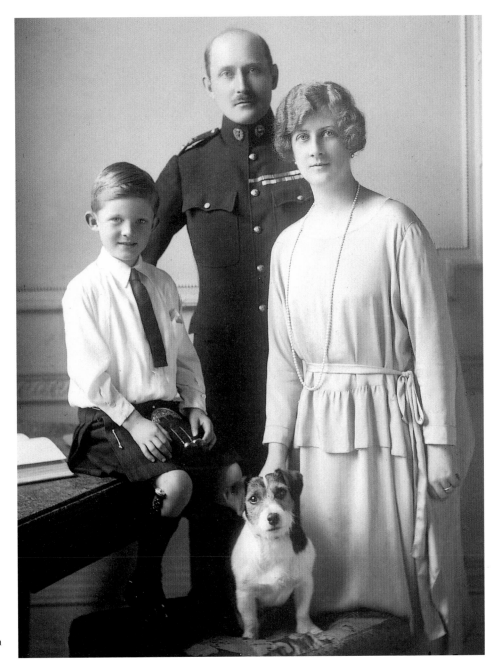

Prince Arthur of Connaught
with his wife Princess
Alexandra, granddaughter
of King Edward VII, and
their only child Prince
Alastair, Earl of MacDuff
(1914–43). Seated with them
is their fox terrier, Vimy.

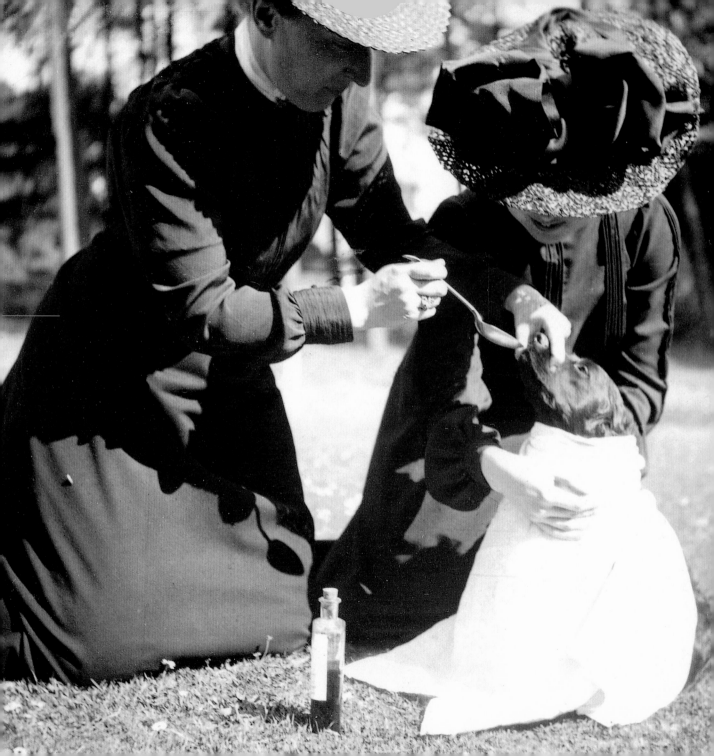

These two photographs of Princess Helena Victoria of Schleswig-Holstein and Princess Margaret of Connaught 'dosing' a dog come from Princess Helena Victoria's personal photograph album and date to 1901. Both women were granddaughters of Queen Victoria: Princess Helena Victoria (1870–1948) was the daughter of Princess Helena (the fifth child of Queen Victoria) and Princess Margaret was the daughter of Prince Arthur, Duke of Connaught.

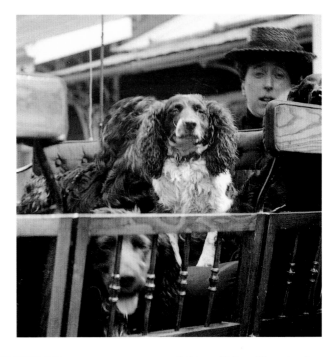

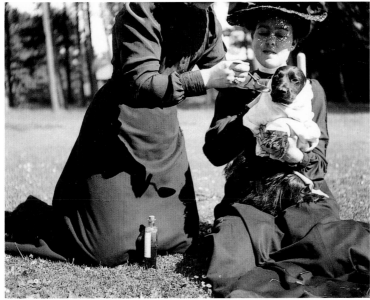

Princess Helena Victoria of Schleswig-Holstein in a cart with some of her dogs in 1901.

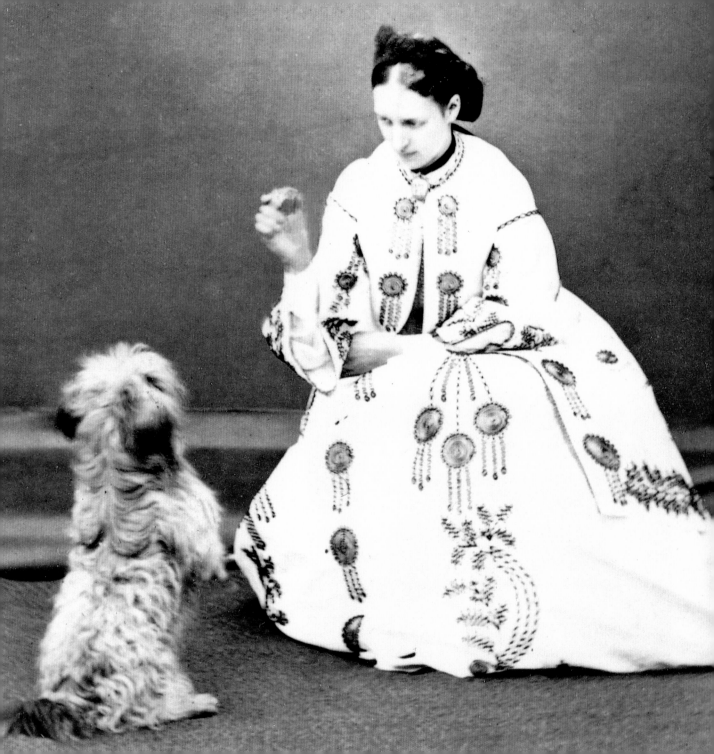

King Edward VII and Queen Alexandra

The Princess of Wales (later Queen Alexandra) plays with a terrier. Alexandra married the Prince of Wales, later King Edward VII, on 10 March 1863. Her first child, Prince Albert Victor, was born on 8 January 1864. She is photographed here in July 1864.

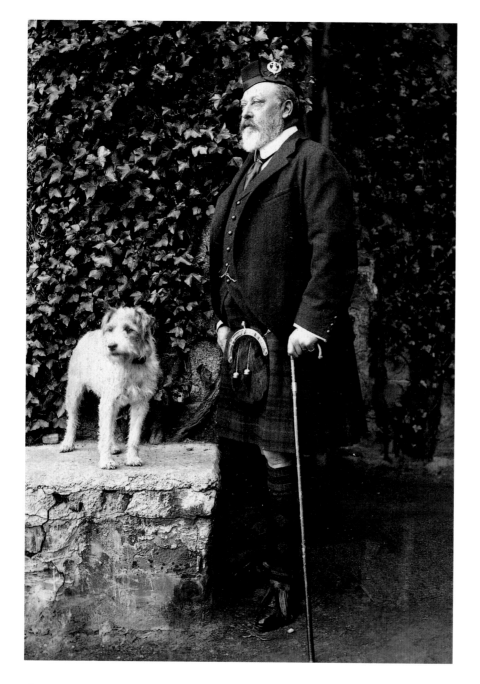

King Edward VII with his terrier
Caesar, 1908. Caesar outlived
the King and (page 67) walked
behind his coffin in the funeral
procession.

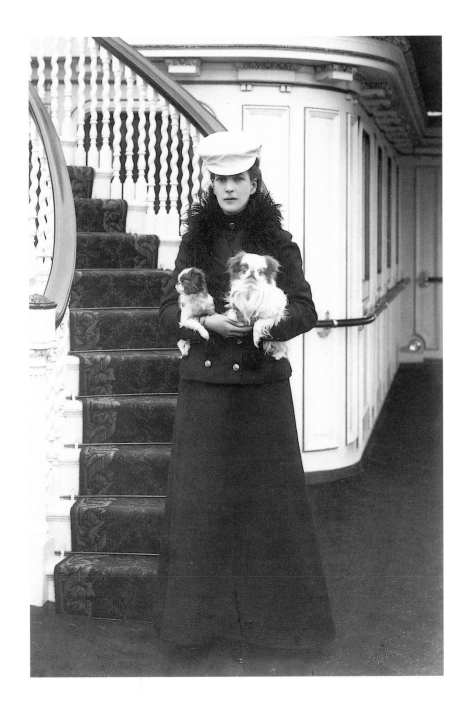

Queen Alexandra, standing on board HMY *Victoria and Albert* in 1904, holds two of her favourite dogs, a Japanese Chin and a Tibetan Spaniel.

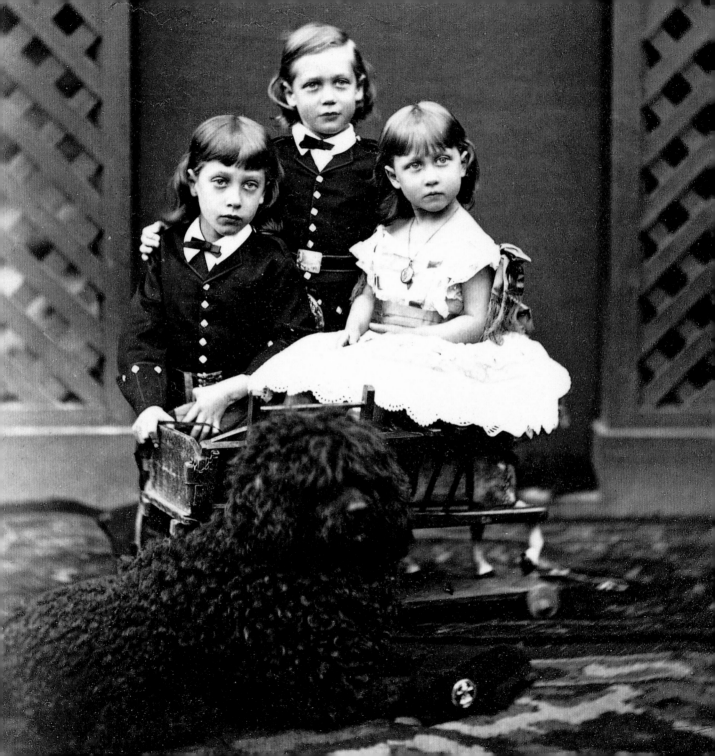

Left: The three eldest children of King Edward VII and Queen Alexandra photographed with a pet poodle in September 1870. On the left is Prince Albert Victor (1864–92), later the Duke of Clarence; in the middle stands Prince George (1865–1936), who in 1910 became King George V, and on the right sits Princess Louise (1867–1931).

Right: Princess Louise of Wales with her dachshund in September 1870. Princess Louise was the third child and eldest daughter of King Edward VII and Queen Alexandra. She was created Princess Royal in 1905.

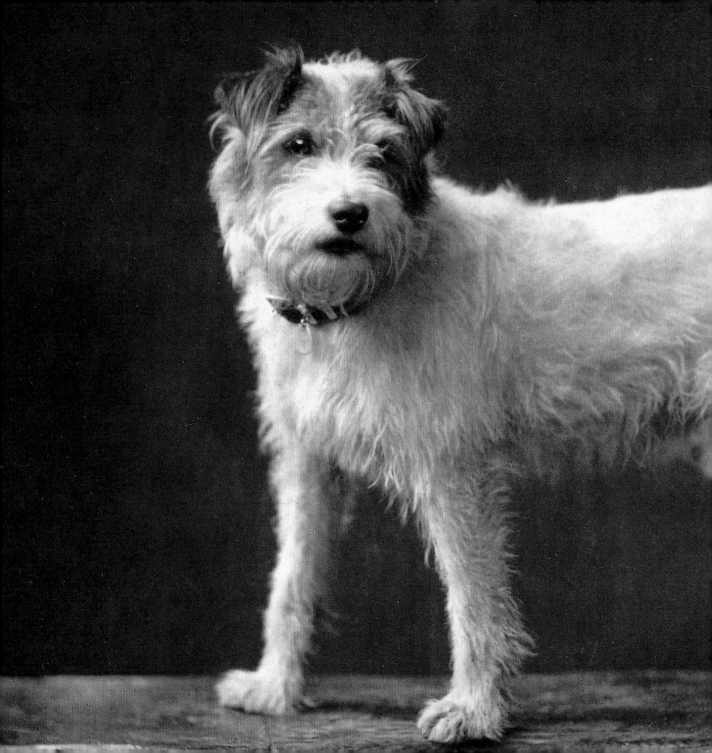

King Edward VII's sitting room in Windsor Castle, 1905–10. A porcelain dog bowl can just be seen underneath the small table by the fireplace. The painting above the fireplace is Sir Edwin Landseer's *Windsor Castle in Modern Times* (see page 9).

Left: Caesar, King Edward VII's terrier, in 1910, the year of the King's death.

Right: Caesar in King Edward VII's funeral procession on 20 May 1910. He walks behind the late King's horse.

Below: This miniature figure of Caesar is made of chalcedony, with ruby eyes and gold collar stating 'I AM CAESAR. I BELONG TO THE KING'. It was one of the first miniature models to be made by Fabergé as part of his royal commission in 1907. When the wax models of the animals at Sandringham were unveiled in December 1907, Caesar was a member of the royal party – with the King and Queen.

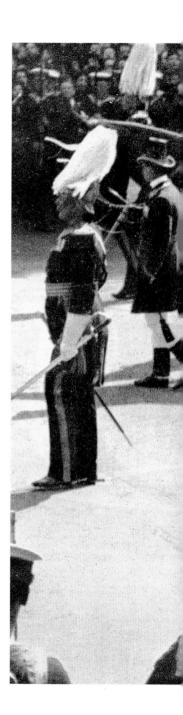

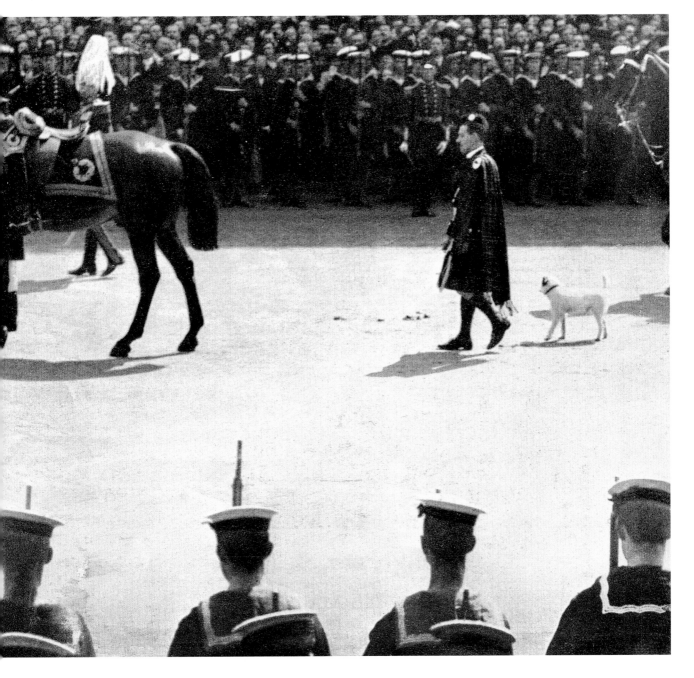

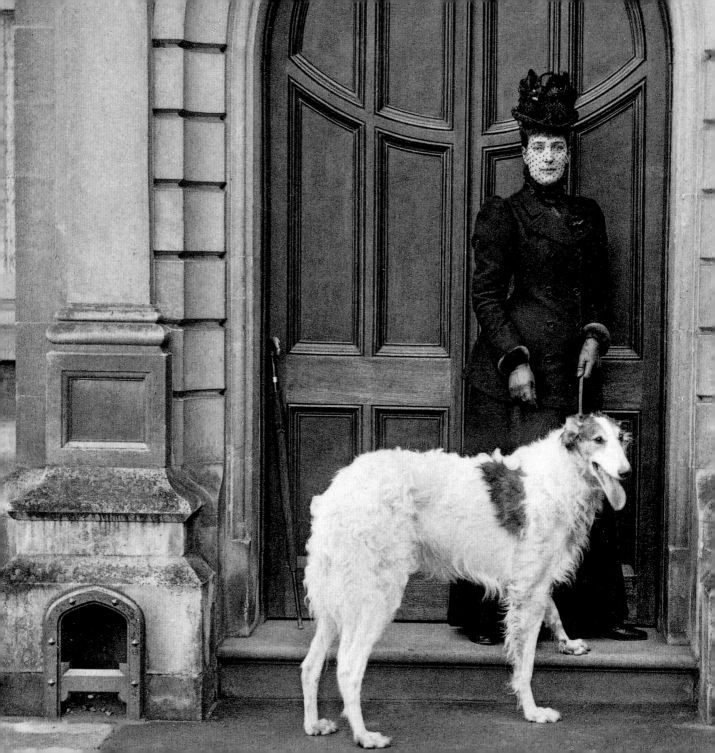

Left: The Princess of Wales in the 1890s with Alex, one of her Borzois. Thomas Fall, the photographer, was noted for his photographs of dogs.

Below: Fabergé's silver Vassilka, commissioned by King Edward VII in 1907. Vassilka was born on 18 May 1902, and was a gift from Tsar Alexander III and Tsarina Maria Feodorovna, sister to Queen Alexandra. He won over 75 prizes.

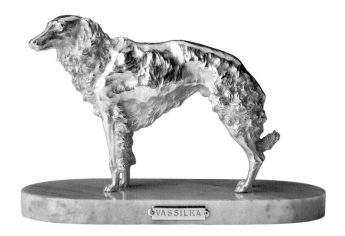

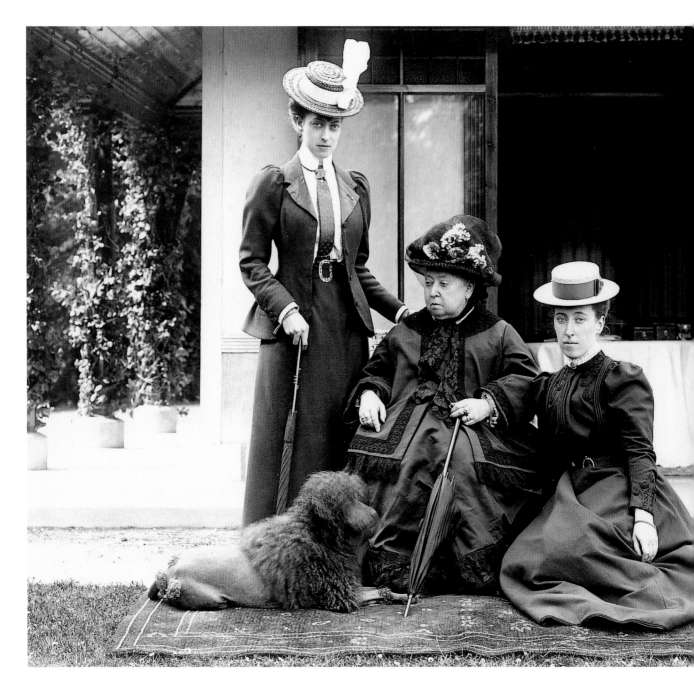

Left: Queen Victoria at Balmoral in 1898 with two of her granddaughters, Princess Victoria of Wales (1868–1935), daughter of King Edward VII and Queen Alexandra; and Princess Helena Victoria of Schleswig-Holstein (see also pages 56–7). At their feet is Sammy the poodle, who belonged to Princess Victoria of Wales.

Below: Princess Victoria of Wales with Sammy in the grounds of Balmoral in June 1898.

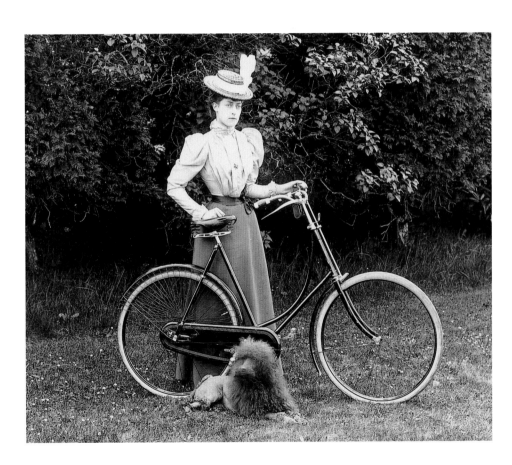

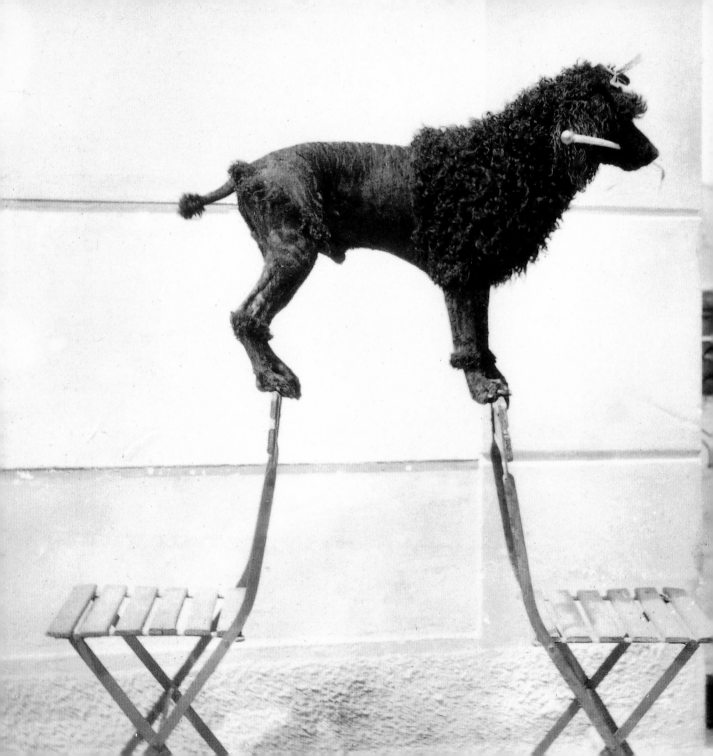

Left: Sammy demonstrating his acrobatic skills, balancing on two chairs while holding a cane in his mouth.

Right: A page from Princess Victoria's album showing her mother, the Princess of Wales (later Queen Alexandra) with Sammy and other dogs at the Sandringham kennels in 1895.

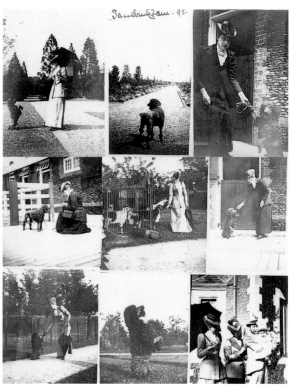

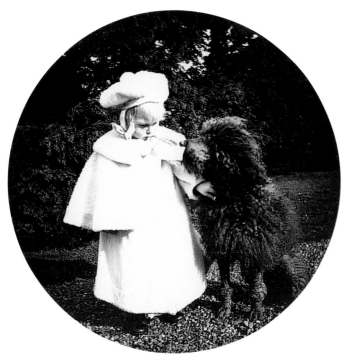

Prince Edward of York (later King Edward VIII) with Sammy the poodle, at Sandringham in November 1896. Sammy met a tragic end at Osborne after accidentally eating rat poison.

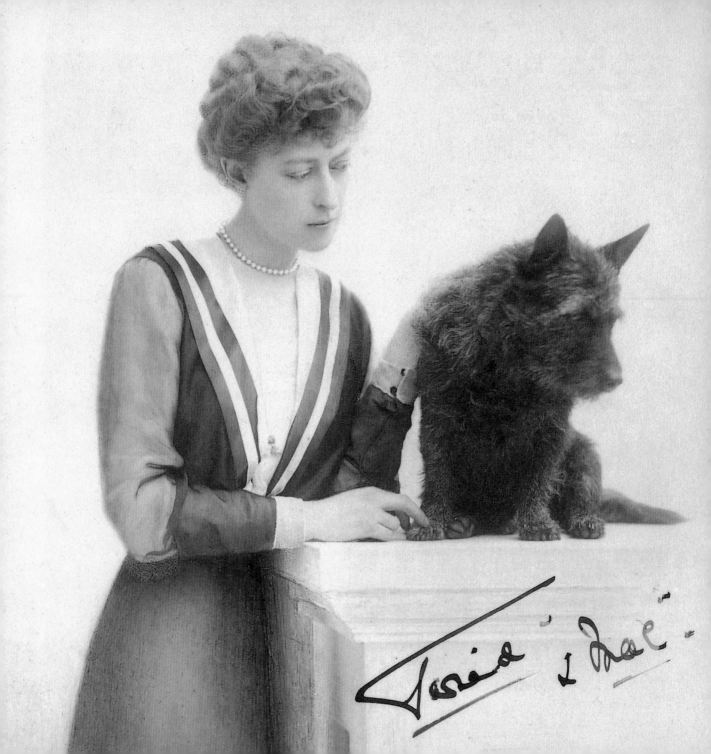

Princess Victoria of Wales with her terrier Mac in 1915. Princess Victoria never married and spent a great deal of time with her mother, often joining her on her travels. Mac usually accompanied her on these trips.

Prince Olav of Norway (1903–91) with Mac on board HMY *Victoria and Albert* in 1908. Prince Olav (King Olav V of Norway from 1957) was the son of Prince Carl of Denmark and Princess Maud (1869–1938), the youngest daughter of King Edward VII. He was born Alexander, Prince of Denmark, and was given the name Olav when his father ascended the Norwegian throne as King Haakon VII in 1905.

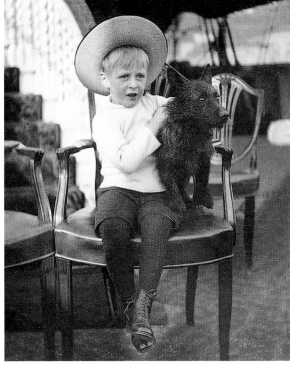

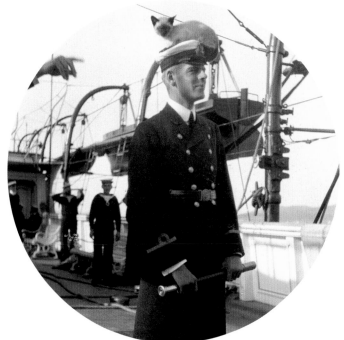

Mac was not the only pet to enjoy a cruise on the royal yacht: 'Lieut. Watson and my cat,' photographed by Queen Alexandra on board HMY *Victoria and Albert* in 1905.

This photograph (possibly taken by Princess Victoria) and dinner menu come from an album compiled by the Princess, covering the period between April 1904 and April 1906. The photograph shows Princess Victoria's terrier Mac on board HMY *Victoria and Albert*, facing a furious-looking Siamese cat. The encounter seems to have later inspired the sketches on the dinner menu, which was signed by everyone who attended.

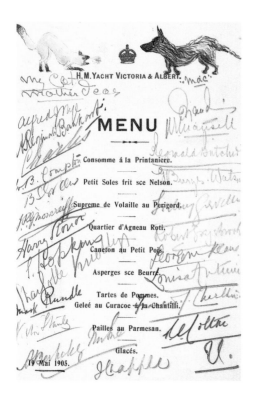

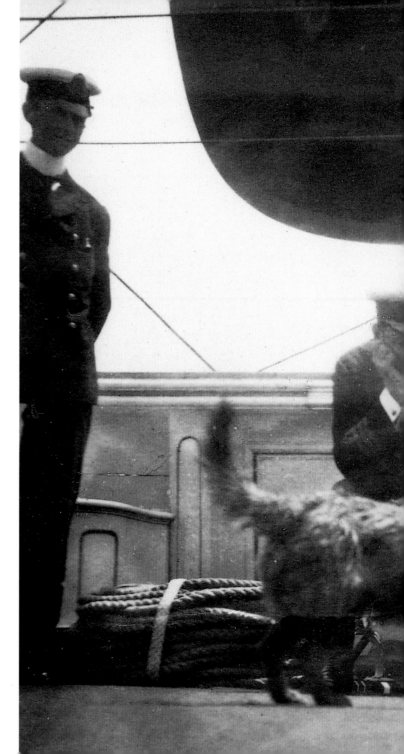

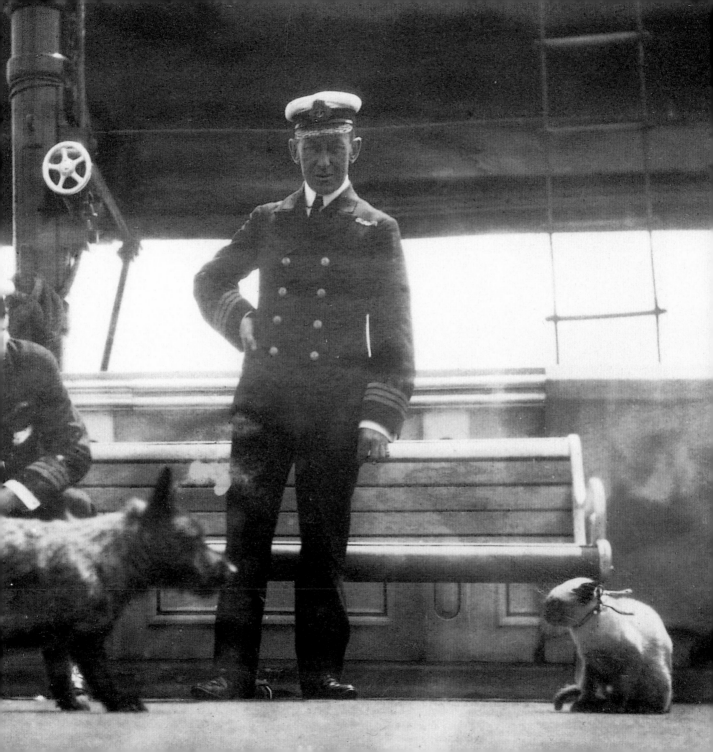

One of Queen Alexandra's dogs
performing tricks. These
photographs are from an album
compiled by Princess Victoria in
1907–8, containing many such
snaps of family life, especially
playing outdoors with pets.

Queen Alexandra, accompanied
in her carriage by a Pekingese or
Tibetan Spaniel in 1910.

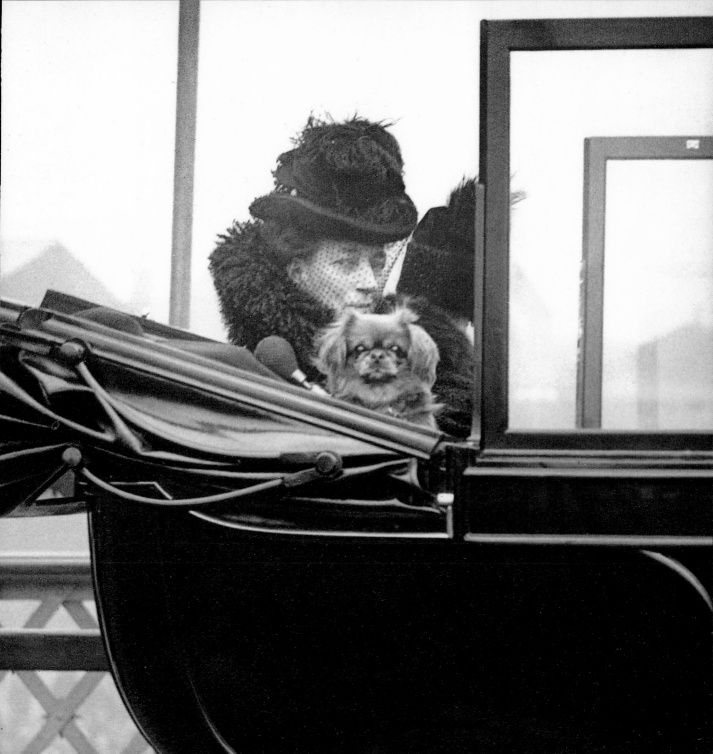

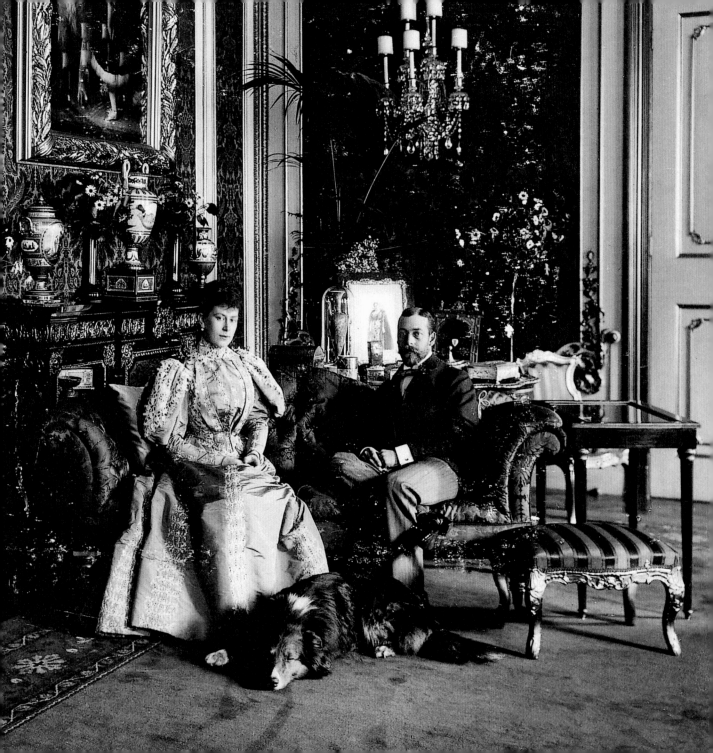

King George V and Queen Mary

The Duke and Duchess of York, photographed in York House, St James's Palace, with their collie Heather in 1896. The Duke of York married Princess Victoria Mary of Teck in 1893. From 1901 they were known as the Prince and Princess of Wales, and following the death of King Edward VII in 1910 they became King George V and Queen Mary.

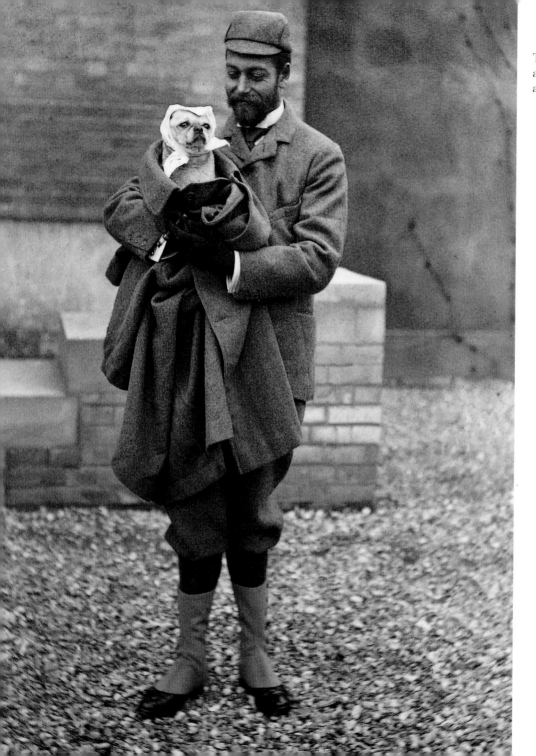

The Duke of York, *c*.1895,
and a pug, wrapped in
a coat and 'headscarf'.

Right: The future King George V poses for a formal portrait with his terrier, Happy, while at Abergeldie Castle near Balmoral in Scotland, *c*.1906. The Prince often used the castle during the summer months, before he became King.

Below: Jack, the King's terrier, in 1920. He was named after King Edward VII's favourite dog.

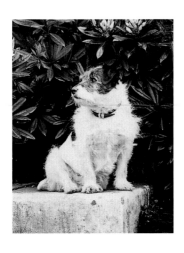

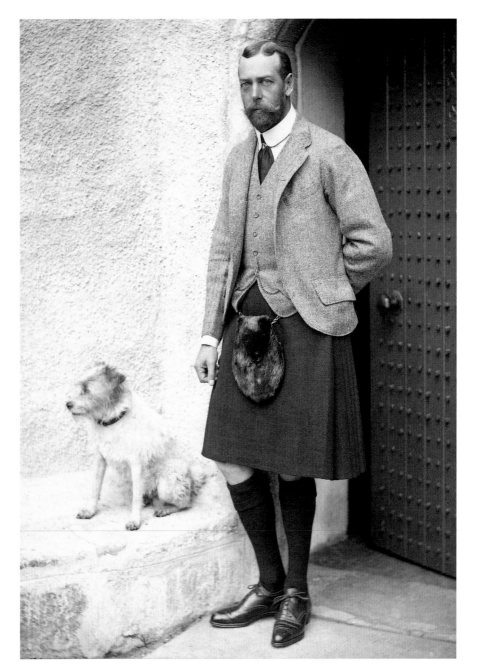

A young Princess Elizabeth at Balmoral in September 1928 with her grandparents, King George V and Queen Mary. The King is having a word with Snip, his Cairn terrier.

Princess Elizabeth with King George V's parrot, Charlotte. Watching closely are Queen Mary, Snip the Cairn terrier, and Alexander, Earl of Athlone (Queen Mary's brother).

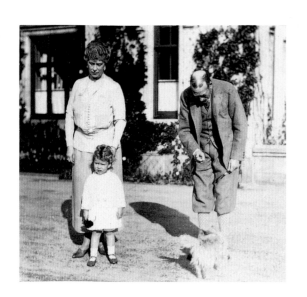

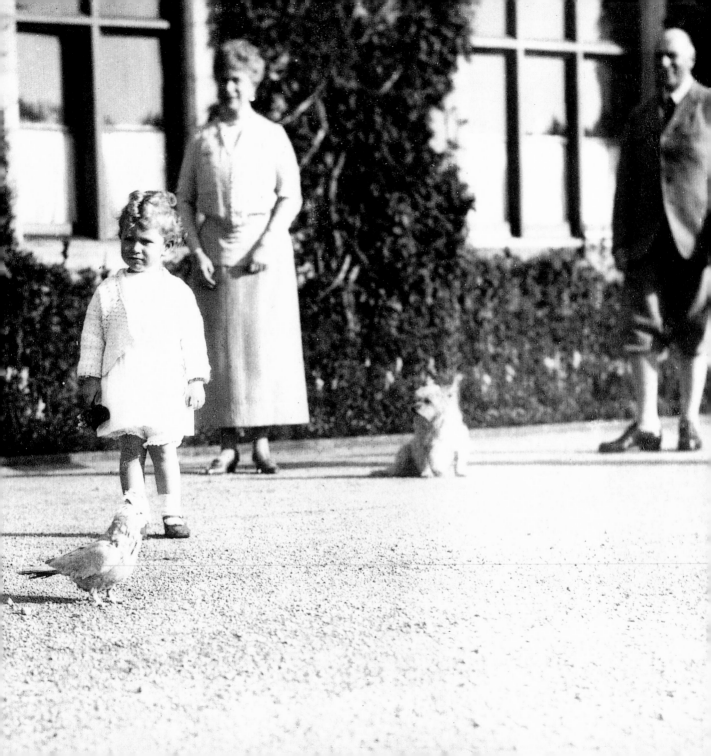

King George V wades through
Loch Muick near Balmoral,
followed by Snip.

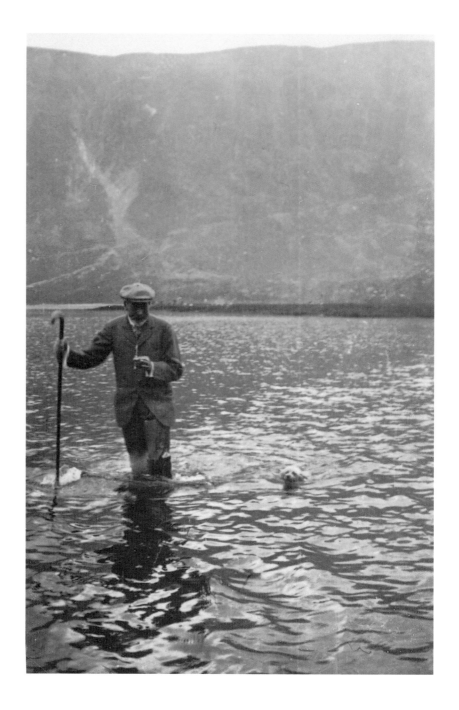

Right: Bob, another Cairn
terrier, was King George V's
last dog. He outlived the
King, dying in September
1938. Bob is shown here
on guard duty at Windsor
Castle in 1937.

Below: Bob's collar,
with the inscription:
'I BELONG TO THE KING'.

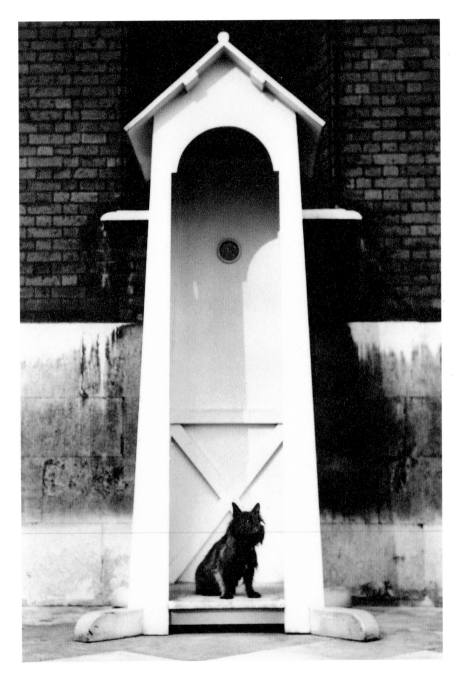

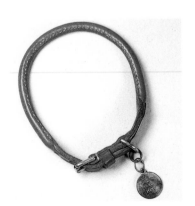

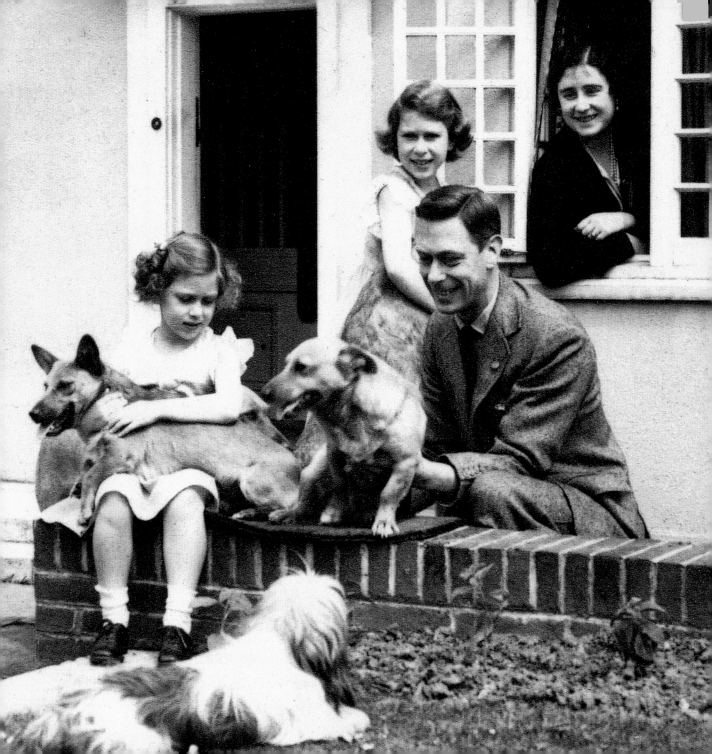

From King George VI
to Queen Elizabeth II

The Duke and Duchess of
York, later King George VI
and Queen Elizabeth, and
their two daughters at
Y Bwthyn Bach, Windsor,
in 1936. The dogs are
Dookie and Jane (corgis),
and Choo-choo (a Tibetan
lion dog, today known as
a Shih Tzu). The child-size
house *Y Bwthyn Bach* was
a gift to Princesses Elizabeth
and Margaret from the
people of Wales.

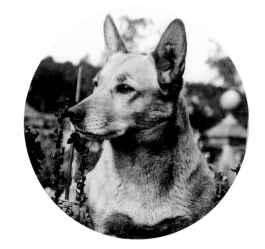

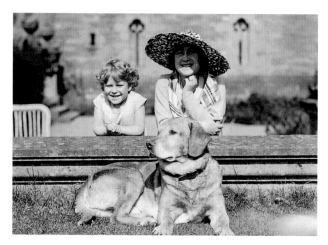

Left: The Duchess of York and Princess Elizabeth, photographed at Glamis Castle in Scotland by the Duke of York in 1930. Glamis was the childhood home of Lady Elizabeth Bowes Lyon and she later made frequent visits there with her family.

Right: Princess Margaret was born at Glamis Castle on 21 August 1930. Here she is, photographed by her father, sitting surrounded by dogs on the steps at Birkhall in Deeside. Scotland. in 1933.

These three photographs were taken at Glamis in 1925. They show the Duke and Duchess of York with their yellow Labrador, Glen. All the photographs on this page come from one of King George VI's photograph albums.

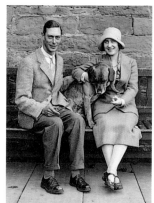

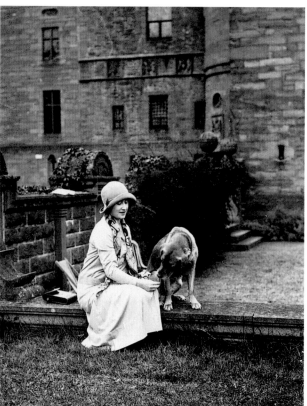

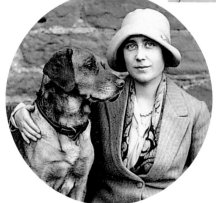

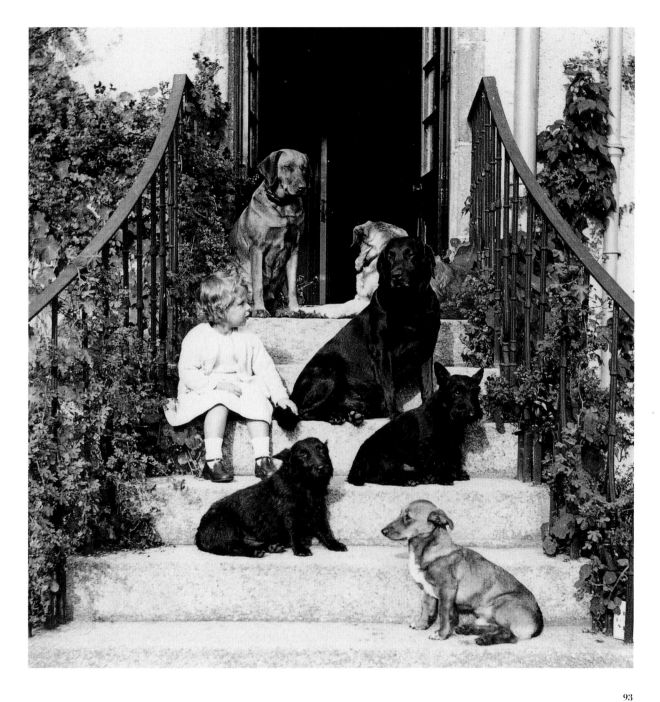

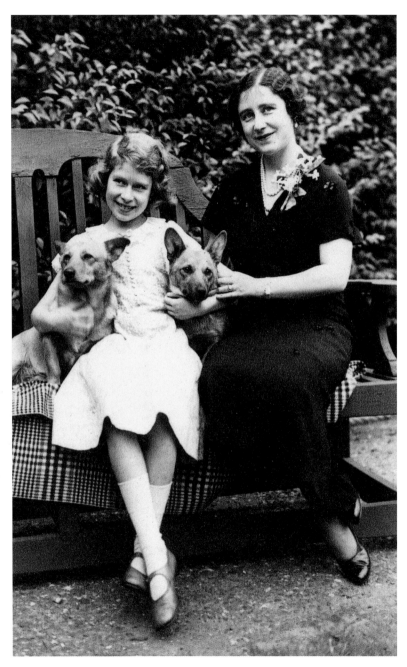

Left: Princess Elizabeth and her mother the Duchess of York in 1936, with Dookie and Jane.

Right: Princess Elizabeth with Dookie. When this photograph was published in 1936, it was suggested that Dookie was 'unquestionably the character of the Princesses' delightful canine family' as well as being 'a born sentimentalist'.

Below: The Duchess of York holds Jane, the second corgi to be acquired for Princess Elizabeth.

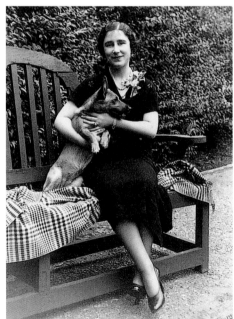

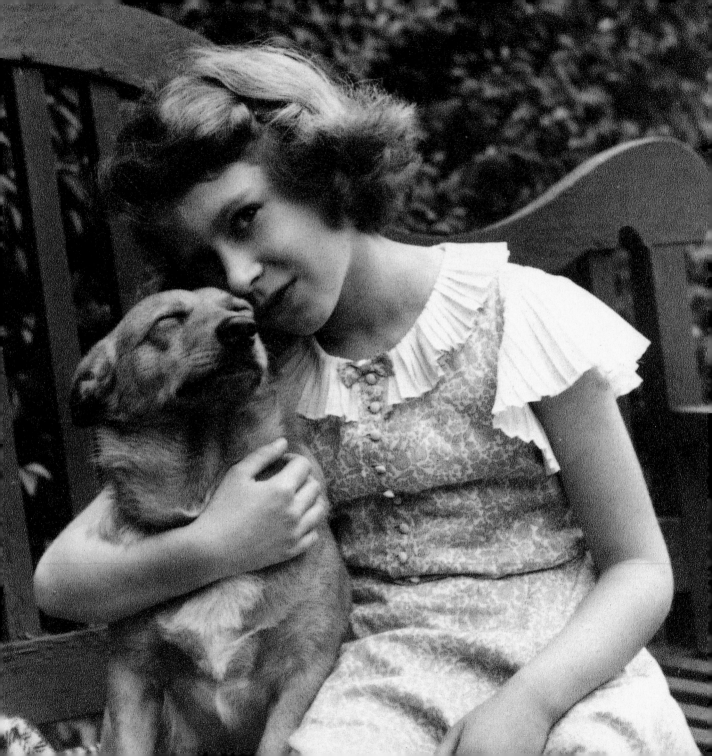

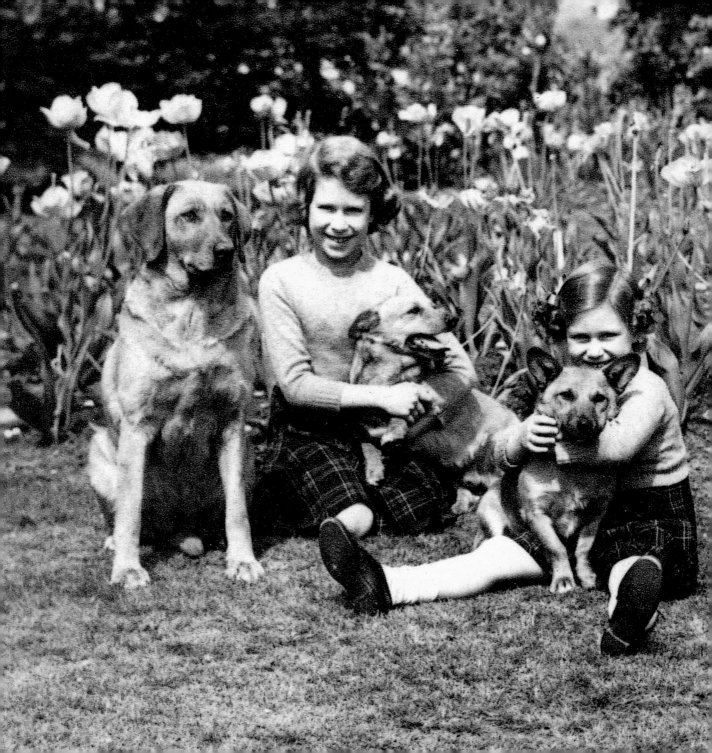

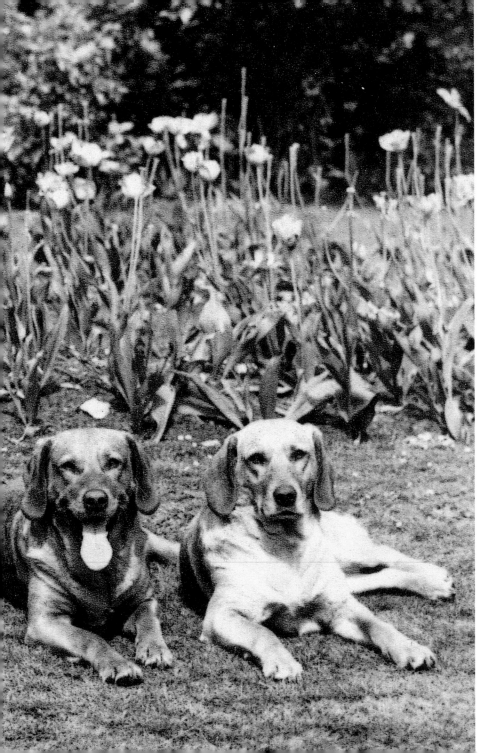

The Princesses Elizabeth and Margaret at Royal Lodge, Windsor, in 1936, with three yellow Labradors – Mimsy, Stiffy and Scrummy – and the two corgis, Dookie and Jane.

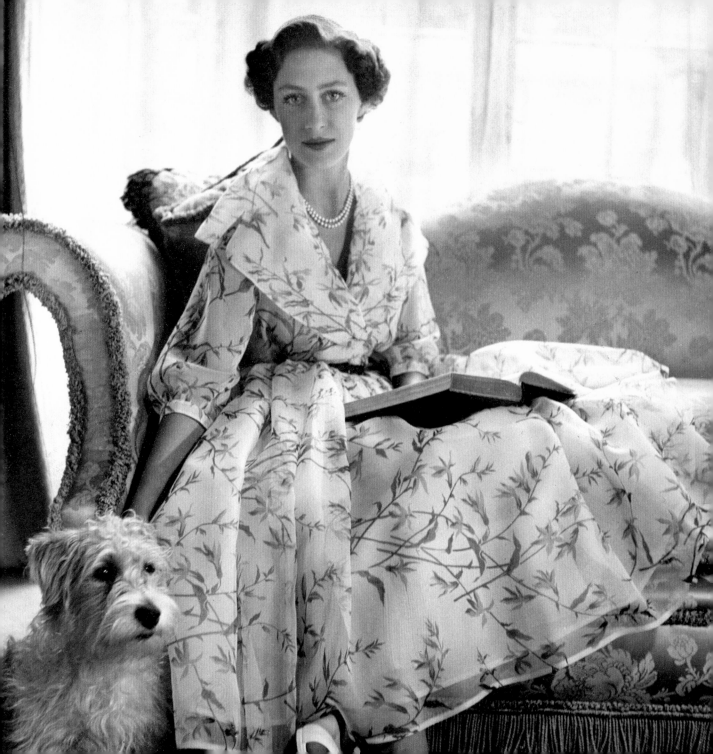

Princess Margaret with her Sealyham terrier, Pippin, in 1954. Like the corgi, the Sealyham originates from Wales, deriving its name from Sealy Ham, the estate in Haverfordwest of Captain John Edwards, who bred the terriers.

King George VI with a corgi. This is one of a series of shots taken by the society photographer Baron for the King and Queen's Silver Wedding Anniversary in 1948.

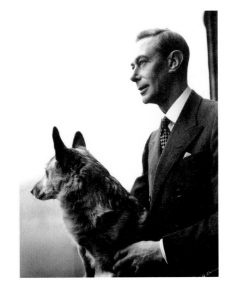

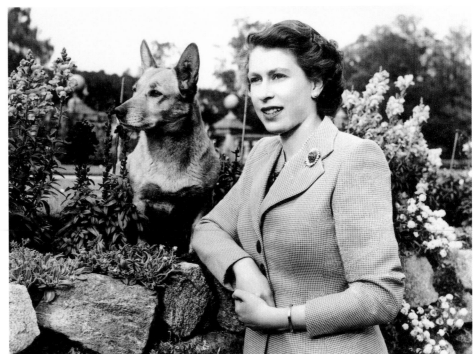

HM The Queen photographed in 1952 with Susan, the corgi that she had received on her eighteenth birthday. All subsequent corgis bred by The Queen have been descended from Susan.

Noble Hounds and

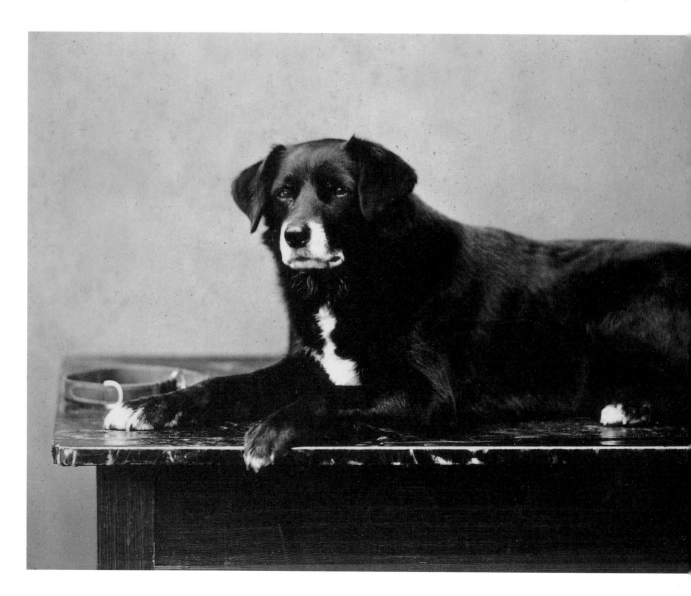

Dear Companions

and two cats . . .

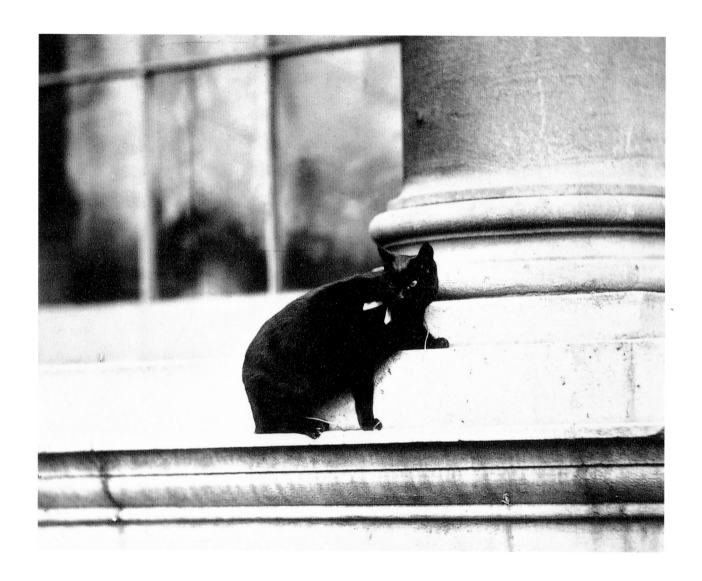

'Peter, a favourite cat in the
Royal Stables, 26 March
1857'. The photograph was
taken by Leonida Caldesi,
and shows Peter outside
Buckingham Palace.

Snowdrop, who belonged to
Prince Leopold, was
photographed in July 1856
by William Bambridge.

Queen Victoria and Prince Albert

From an early age, Queen Victoria was devoted to dogs. She wrote about her Cavalier King Charles Spaniel, called Dash, in her journal for 1833, describing how she dressed him up in a jacket and trousers. A portrait in oils of Dash, by the noted animal artist Edwin Landseer, was given by the Duchess of Kent, Queen Victoria's mother, to her daughter as a seventeenth birthday present (see page 8).

When Dash died in December 1840, he was buried in the grounds of Windsor Castle, with an epitaph that illustrates clearly the devotion the young Queen felt for him.

> His attachment was without selfishness,
> His playfulness without malice,
> His fidelity without deceit.
> READER, if you would live beloved and die regretted, profit by the example of DASH.

At the beginning of the same year, Queen Victoria had married Prince Albert. Her new husband also had a great love of dogs. Prince Albert's elegant greyhound Eos accompanied him from Germany when he travelled to Britain to marry the Queen. Eos followed them on the honeymoon as well, spent at Windsor. Named after the Greek goddess of the dawn, Eos was painted by Landseer, in a portrait commissioned by the Queen for her husband as a Christmas present in 1841 (page 14). She stands alongside Albert's top hat, silk gloves and cane, representing a modern, urbane and sophisticated prince.

When Eos died in 1844, she too was buried in the Home Park at Windsor, and a statue, based on the Landseer portrait, was erected to her memory.

Greyhounds remained popular into the 1860s, although none was to be as loved as Eos. The equally elegant Helios (b.1864), so named because in Greek mythology Helios the Sun God was the brother of Eos, was photographed in the kennels in 1865. The portrait was used as the basis for the cover of the kennels album (page 10). Also photographed was the striking Harlequin (b.1863), who as his name suggests, had a black and white patterned coat. More unusual was the greyhound Giddy (a gift from Lord Lurgan), whose fur was patterned with white polka-dots.

A year after the death of Eos, another dog arrived in Windsor from Coburg. Following an idyllic visit that the couple made to Prince Albert's birthplace, Schloss Rosenau, Queen Victoria brought Deckel the dachshund back with her to England. Deckel was painted by Landseer in 1847 and, until his death in 1859, was a constant companion of the Queen. He appeared in family group portraits, with other members of the royal family, as well as with Mr Cowley, one of Prince Albert's *jägers*.

The grave of Eos in the Home Park at Windsor.

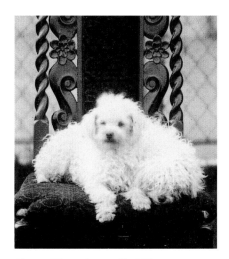

Above: These dogs, called Chico and Goliah, are described as 'Cuba dogs', and are probably the breed known today as a Bichon Havanese. Chico was born in 1853 and died on 28 May 1858. Goliah, given to the Queen by Lady Ellesmore in 1854, was born in 1853 and died in March 1857.

Right: Queen Victoria at Balmoral with members of her family and Turi, her Pomeranian, in 1895. From left to right, standing: Princess Helena Victoria; Prince Henry of Battenberg; Count Arthur Mensdorff; Princess Beatrice; and the Duke of York (later King George V). Seated: Queen Victoria; Prince Edward of York (later King Edward VIII); and the Duchess of York (later Queen Mary). On the ground: Prince Arthur of Connaught and Prince Alexander of Battenberg.

Deckel was not the first dachshund to arrive in the Royal Household; archive records indicate that several dachshunds were sent over from Coburg throughout the 1840s. However Deckel was certainly the first to hold a strong place in the Queen's affections. He was followed by several generations of dachshunds, including Dacko who arrived in February 1859 and lived until December 1871, and most notably, Waldman. The sixth dachshund to bear this name, Waldman was brought back to Britain by Queen Victoria, following a visit to the German town of Baden in 1872. When he died on 11 July 1881, he was commemorated in a memorial at Windsor, describing him as 'the very favourite dachshund of Queen Victoria'.

Before Waldman VI, there was a succession of Waldmans (and Waldinas, dog consorts). Waldman I had arrived in Britain in 1840 and lived a long life, dying in c.1856. His photograph appears in the kennel albums. Waldman II, probably born in 1842, was given away in 1844. Waldman III, also photographed for the kennel albums, arrived in 1844 and died in 1856. Waldman IV, who arrived in 1850, only lived a year, but Waldman V, whose arrival in the kennels is not recorded, was certainly around in 1858 and he lived until c.1872. Prince Alfred, the second son of Queen Victoria, photographed his brother Prince Leopold playing with Waldman V in April 1865, in the grounds of Windsor Castle (page 22).

The Queen went through periods of her life when she would be attached to one breed in particular. Her attachment to the dachshund was not really replaced

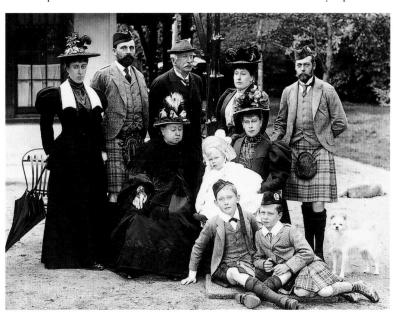

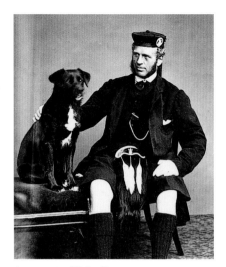

A portrait of John Brown
(1826–83), the Queen's
servant, with her collie Sharp.

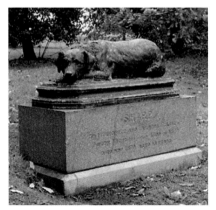

Sharp's grave in the Home Park at Windsor.

until the late 1880s when, following a visit to Italy in 1888, the Queen brought back Marco, a Pomeranian, who quickly became a favourite. Other Pomeranians followed him in the Queen's affections, with as many as 35 in total being recorded in the kennels. In 1891, the Queen was even persuaded to show six of her beloved Pomeranians in the first Crufts dog show: Fluffy, Nino, Mino, Beppo, Gilda and Lulu.

One of the last dogs that the Queen owned, and who was at her side when she died, was a Pomeranian called Turi. He was often seen accompanying the Queen on her carriage drives in the last few years of her life. Turi also often appears as one of the family in group portraits. After the Queen's death, Turi was given to the Duchess of Albany, the widow of Prince Leopold.

During the 1860s and 70s, the Queen became fond of smooth-haired collies, although they were generally kept as 'outside' dogs. The breed had previously not been particularly popular, but once the Queen had shown an interest, collies became more fashionable and began to appear in show rings around the country. The first collie kept as a pet by the Queen was called Sharp (1864–79), although at least two working collies are recorded in the kennels in the 1840s. Sharp was photographed in 1866 with Queen Victoria in a series of well-known images where she seems to hold him in a particularly affectionate and tender way. The photographs were available to the public as cheap cartes-de-visite – small, business card-sized photographs, which were sold widely like postcards. They no doubt contributed to the growing popularity of the collie, as well as presenting a portrait of a relaxed and happy sovereign. Sharp was, like many of the Queen's favourite dogs, painted by Landseer, and following his death, he was buried in the grounds of Windsor Castle.

Noble succeeded Sharp in the Queen's affections. He was given to Queen Victoria at Balmoral on 24 May 1872, and he was to die at Balmoral on 18 September 1887. There had previously been two other collies called Noble, but it was Noble III that became a favoured pet. There was also a Noble IV and V, and it is probably the latter who is described as 'Young Noble' in the photograph, taken in 1886, which shows Noble III with his grandson (page 41). Noble III also lived to see the arrival of his great grandchildren. Their mother Regina (1881–5), was given to the Queen by the Duchess of Roxburghe, and she was photographed looking very proud with a litter of puppies at the kennels in Windsor.

Noble was photographed and painted on several occasions with his friends Fern (another collie, c.1876–86), Waldman VI and Wat, a smooth-haired fox terrier who actually belonged to Princess Beatrice, but who was much loved by the Queen. The four dogs seem to have spent a great deal of time together, especially at Balmoral, where they were exercised as a group by the ghillies who

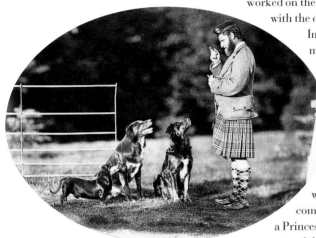

The ghillie Francis Clark calls Noble, Fern and Waldman to attention at Balmoral.

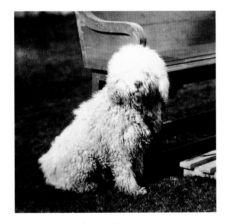

Milor, a French poodle, was a gift to the Prince of Wales in 1854 from Lord Alfred Paget, the Queen's Chief Equerry and Clerk-Marshal.

worked on the estate. Francis Clark was photographed on a few occasions with the dogs, apparently trying to keep the lively group under control.

In all, the Queen owned as many as 88 collies during her lifetime, more than any other breed of dog recorded in the kennels.

There were at least six more dogs with the name Sharp, one of which was photographed as a puppy, and another two collies called Fern.

Apart from the personal pets that spent a great deal of time with the Queen, there were at any time between 70 and 100 dogs in the kennels in the Home Park at Windsor, which were built in 1840–41. The Queen would often drive down to the kennels to see the dogs, and had a great concern for their welfare. At a time when tail docking and ear cropping was common, the Queen forbade it for any dogs in the kennels. While still a Princess, the Queen had taken an interest in animal care, providing support with her mother, the Duchess of Kent, for the Society for the Prevention of Cruelty to Animals. After she ascended the throne in 1837, the Queen became the Patron of the Society, and it took on the name it holds today: The Royal Society for the Prevention of Cruelty to Animals (RSPCA). Queen Victoria in addition took on the patronage of Battersea Dogs Home, founded in 1885. Following her death in 1901, her son King Edward VII succeeded her as patron. The King also cared deeply about the welfare of animals, becoming the first patron of the Kennel Club. In 1879 he spoke out publicly against the practice of ear cropping, and was largely responsible for turning fashion against this practice. Another of Queen Victoria's sons, Prince Leopold, visited Battersea Dogs Home in 1882 and acquired one of the rescue dogs, a terrier called Skippy. The dog was photographed a few years later with Prince Leopold's young daughter, Princess Alice (page 31).

The dogs at the Windsor kennels were both domestic pets and working dogs. Some arrived at the kennels as gifts to the Queen, such as the beautiful but sad-looking 'Cashmere' dog called Bout who was really a Tibetan Mastiff, or the Pekingese 'Looty' who became something of a celebrity in his own right, after having his portrait published in the *Illustrated London News* in June 1861. Captain John Hart Dunne had discovered Looty in early October 1860 in China, when British and French troops entered the Chinese Emperor's Summer Palace, the Yuanming Yuan, near Beijing, during a conflict that would become known as the Second Opium War. According to Dunne's account, Looty was one of five dogs guarding the dead body of the Emperor's aunt. Dunne rescued Looty, describing him as 'a most affectionate and intelligent little creature – it has always been accustomed to be treated as a pet and it was with the hope that

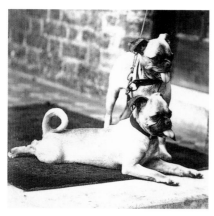

Rosa and Minka, the puppies of Jetty, were born on 5 July 1864 and photographed the following year.

Quarry, a Russian dog, brought back from Sebastopol. British troops were in Russia during the Crimean War (1854–6). The Siege of Sebastopol began on 17 October 1854 and was eventually to be a victory for the British and French troops, in September 1855. Quarry was presumably brought back by a member of the British military force and was presented to Queen Victoria on 14 November 1855.

it might be looked upon as such by Her Majesty and the Royal Family that I have brought it from China.' When Looty was presented to Queen Victoria, he was the first Pekingese dog to arrive in Britain (page 33). Being such an unusual animal, Looty was photographed and painted on several occasions. He died on 2 March 1872, aged (it was believed) about sixteen years old.

William Bambridge was the first photographer employed to record the royal dogs in the Windsor kennels in 1854. The images he created were incorporated into albums, which were subsequently added to over the years with further photographs of newly arrived dogs. The name of the dog would always be included in the caption below the photograph, with birth and death dates when known, and sometimes the dog's pedigree. Along with the photographs, lists of the animals in the kennels were drawn up: the earliest list seems to have been made in 1844, the last was made in 1897, only a few years before the Queen's death. The lists, along with the photograph albums, are the principal source of information on the Queen's dogs. They tell us that, apart from the greyhounds, dachshunds, Pomeranians and collies which became the Queen's pets, there were three other breeds that were particularly numerous in the kennels: smooth-haired fox terriers, pugs and what were then known as Scotch terriers, which was a catch-all name used to describe a variety of terrier-like dogs from Scotland.

Pugs were acquired in the kennels throughout the Queen's life. The first pug to arrive was probably the unnamed dog mentioned in the *List of Dogs 1846*, given to the Queen in 1845. The early kennel albums contain a number of images of pugs, suggesting that the photographers were particularly drawn to their highly endearing but sometimes slightly comical appearance. Venus (*c*.1853–60) was photographed looking exceptionally proud with her two new puppies in 1854. Also included in the same photograph album is a portrait of the two sisters, Rosa and Minka, born in 1864 (see above). One of them lies spread out across the floor, showing the curl in her tail to great advantage. Several pugs had Russian names, such as Minka or Olga, as they were descendants of a puppy that was sent over from Russia as a gift in July 1847.

In all, as many as 38 pugs were kept in the kennels during Queen Victoria's reign. This appears a relatively small number, however, when compared to the number of Scotch terriers: at least 57 have been recorded. The name of course incorporates several breeds that are today identified separately, including the Dandie Dinmont, the Cairn, the Scottish terrier, the Skye terrier and the West Highland terrier. In many 19th-century photographs, the characteristics of the breeds are not yet as obvious as they would be in today's pedigree dogs, which demonstrates how quickly selective breeding can have an effect. In addition to the Scotch terriers, at least 23 smooth-haired fox terriers lived in the royal kennels during the 19th century. These dogs were also great favourites, and were

usually given short, monosyllabic names like Spot, Wat, Nip and Skip. Spot was one of the longest-lived fox terriers, arriving in 1880 and living for 16 years. He was photographed with Noble III, trying to smoke a pipe (page 42).

King Edward VII and Queen Alexandra

After Queen Victoria's death in 1901, the dogs remained at Windsor until 1903, when King Edward VII removed all the remaining animals from Windsor to the kennels he had established at Sandringham in 1879.

Several of Queen Victoria's children were, at an early age, given pets to care for as their own. The Princess Royal was given a cat, which Queen Victoria referred to in her diary. Prince Leopold was also given a cat, which he called Snowdrop. It was photographed in 1856 by Bambridge and is one of the few images we have of 'royal cats' in contrast to the hundreds of photographs of dogs (page 103).

Prince Alfred (the Queen's second son) owned terriers from a relatively early age. He took a series of self-portraits in 1864 in which he included his Scotch terrier in a variety of poses. The dog seems to be a large Skye terrier, a breed that had been popular with Queen Victoria as well. At around the same time, the Prince of Wales was photographed with a Skye, affectionately pulling its ear. The Princess of Wales was also photographed with a Scotch terrier in the mid-1860s. The photograph was produced in the small carte-de-visite format, suggesting that the Princess probably intended to send out several copies to friends and family.

Terriers certainly remained the Prince of Wales's favourite type of dog, but he acquired numerous others, usually as gifts. In particular, he was given a beautiful Samoyed by the German Chancellor Otto von Bismarck in 1886. The photograph of the Prince and this dog (see left) was subsequently used as the basis for a painting, which also incorporated the Princess of Wales, and was published in celebration of the couple's Silver Wedding Anniversary in 1888. Both became quite attached to the breed, and acquired several others, in particular Jacko, the Samoyed presented to the Princess in 1899 by Major Frederick G. Jackson, leader of the Jackson-Harmsworth Expedition to Franz Josef Land in the Arctic.

However, the dog which the King was supposed to have liked more than any other was an Irish terrier called Jack. The King greatly admired his independence and general disdain for everybody. One of the stories he enjoyed telling about Jack was how he went out one evening at 7pm, and failed to return. Servants were sent out to search for him but Jack was nowhere to be seen. Two days later, at 2am, Jack wandered back into the house, oblivious to all the fuss he had caused, and the King was greatly amused by his nonchalance.

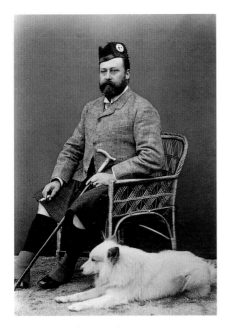

The Prince of Wales, later King Edward VII, sits with his Samoyed, a gift from the German Chancellor Otto von Bismarck.

Jack was accompanying the King and Queen on a visit to Ireland in 1903 when he died quite suddenly whilst the party was staying at the Viceregal Lodge in Dublin. Jack was buried in the grounds of the lodge, and given a moving epitaph which reads,

Here lies Jack, King Edward's favourite Irish terrier who only lived twelve hours after reaching his native land. He died at Viceregal Lodge on July 21 1903.

Following his return to London, the King kept a locket on his writing desk that contained strands of Jack's hair.

Shortly after Jack's death, the King was presented with a terrier called Caesar, bred by the Duchess of Newcastle. Caesar quickly became well known within the Court for his disregard for everyone except the King. Caesar accompanied the King everywhere, to meetings with politicians and on holiday to Biarritz in France. The King was extremely fond of Caesar, and when in 1907 he commissioned Carl Fabergé to make a group of small carved animals, he insisted that Caesar was included (page 66). The model, made in chalcedony with added gold, enamel and rubies, clearly shows Caesar wearing his specially made collar proclaiming 'I am Caesar. I belong to the King.'

Caesar achieved widespread fame in 1910, when in the King's funeral procession he walked behind the coffin of his dead master (page 67). It had been the idea of Queen Alexandra, who took care of the inconsolable dog after the King's death. Photographs and postcards of the dog, walking alongside the guard of honour, touched the hearts of thousands. This was demonstrated by the success of Caesar's book, *Where's Master?* published in June 1910. It was a deeply sentimental publication, supposedly written by Caesar himself, which sold over 100,000 copies. It was already in its fourth edition by July. Caesar died in April 1914, following an operation under anaesthetic. He is buried in the grounds of Marlborough House, where Queen Alexandra lived after King Edward's death.

Queen Alexandra's love of dogs is evident from the number of times she was photographed playing with them, holding a small Japanese Chin or standing with one of her elegant Borzois. The Japanese Chins (usually referred to as Japanese Spaniels at the time) had been brought over to Britain from Japan in the 1880s. The Empress of Japan later sent four dogs to Queen Alexandra as a gift, but sadly only one dog arrived alive in England. They became, however, a favourite breed of the Queen, who was photographed and painted frequently with them. They travelled with her as well, not only between royal residences, but also on cruises and tours throughout Europe.

A number of surviving photograph albums document these tours, showing that the dogs on board ship played an important role in the entertainment of the

Jack's grave in the grounds of the Viceregal Lodge, Dublin.

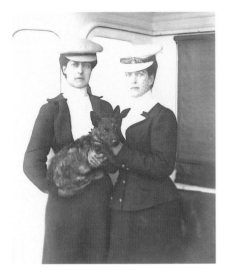

Queen Alexandra with her
daughter Princess Victoria
(1868–1935) on board HMY
Victoria and Albert. Princess
Victoria is holding her terrier
Mac, who accompanied her
on her travels.

crew and passengers. Queen Alexandra's daughter, Princess Victoria, owned a lively Cairn terrier called Mac, and both dog and owner often travelled overseas with the Queen. On one occasion, the crew were photographed watching Mac as he approached an angry looking cat (who belonged to Queen Alexandra). The moment was later preserved on the ship's menu, where Mac and the cat were sketched at the top of the page, and everyone who attended the dinner added their signature. Queen Alexandra has inscribed the menu as 'Mother dear' at the top, and Princess Victoria has signed 'V' at the bottom (page 76).

Queen Alexandra evidently enjoyed the company of small, aristocratic breeds such as Papillons and Pekingese, but she was also well known for the Borzoi dogs that were bred at Sandringham, and entered into many competitions over the years. The first Borzois in the royal kennels were probably the pair Vassilka and Alex, who were presented by Tsar Alexander III of Russia. A pair was also given to King Edward VII (Molodetz and Oudalska). While Alex went on to win many prizes, it was Vassilka who achieved Champion status through various shows. King Edward VII commissioned a model in silver of Vassilka in 1907 from the Fabergé workshop (page 69).

The Queen was greatly involved in the lives of the dogs in the kennels at Sandringham, and is said to have been a frequent visitor. She knew the names of the animals and sometimes fed them herself. Following the death of King Edward VII in 1910, the Sandringham kennels remained under the care and guidance of Queen Alexandra. King George V left them for the use of his mother, while he made use of the kennels at nearby Wolferton for his own gundogs until Queen Alexandra's death in 1925.

King George V
and Queen Mary

The Duke of York
with a terrier.

King George V took an active interest in the working dogs at Wolferton kennels (and later at Sandringham). Clumber spaniels, previously popular during Prince Albert's lifetime, were said to be particular favourites, as were Labrador Retrievers. Unusually, several of the King's working dogs were photographed and some were entered into local dog shows. Sandringham Strapper, bred by the King, was shown in the King's Lynn and District Kennel Society's Open Dog Show in September 1933.

The King had five dogs that he kept as personal pets. The first was a collie called Heather (d.1904), who lived to be 11. Heather was photographed at the feet of the future King and Queen in the formal surroundings of St James's Palace (page 82) even though it was still relatively unusual to find such large dogs indoors at this time. Following Heather's death, the King acquired Happy, the first of four terriers he was to own. Happy (d.1913) was a crossbreed, and following in Caesar's footsteps, he became an author with the publication of *If I were King George*, which was published in April 1911.

Sandringham Strapper, a Labrador Retriever, owned by King George V. Bred by the King, this dog was exhibited in the King's Lynn and District Kennel Society's Open Dog Show, in September 1933.

The King's third dog was a Sealyham terrier called Jack, who was named after King Edward VII's favourite dog Jack. He died in 1928, aged 14, and was followed by Snip, a Cairn terrier. Given to the King by his daughter Princess Mary, Snip became a companion to the King's parrot, Charlotte. Both Charlotte and Snip are shown in front of Balmoral Castle being followed by a young Princess Elizabeth. Closely observing is Queen Mary.

The last dog owned by the King was Bob, another Cairn. Bob outlived the King, dying in 1938. Bob was photographed in 1937 on guard duty at Windsor Castle.

From King George VI to Queen Elizabeth II

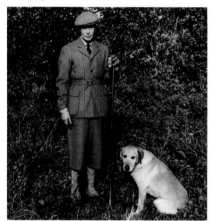

King George VI was known for his interest in the yellow Labrador Retriever, both as a gun dog and as a pet. The dogs were bred at Sandringham and registered at the Kennel Club with the 'Sandringham' prefix. The yellow Labrador was relatively uncommon in the early 20th century; the first recorded appearance of this colour coat was not until 1899.

King George VI also owned a number of Labrador Retrievers as gun dogs and as pets. He bred in particular the yellow Labrador, and this is evident in a number of photographs. A charming family group, photographed in 1936, shows King George VI with Queen Elizabeth, and their two daughters, Princesses Elizabeth and Margaret. With them are a Tibetan lion dog called Choo-choo and two Pembroke corgis, called Dookie and Jane (page 90). The first corgi was acquired in 1933, apparently following a request from the Princesses. They used to play with the children of Viscount Weymouth (later the Marquess of Bath) who owned a Pembroke corgi. They enjoyed playing with the dog so much that they asked if they could have one of their own. Consequently, Rozavel Golden Eagle (known as Dookie) was acquired, and shortly afterwards Rozavel Lady Jane. Dookie acquired his nickname when he was sent away to be trained. The servants in the house, aware that the dog was destined for the household of the Duke of York, began to refer to him as 'Dookie'. When the dog returned to his new family, it was admitted that he now only responded to that name, and so it remained with him.

In June 1936, a photographic session was held at Royal Lodge, the country home of the Duke and Duchess of York in the Great Park at Windsor. Here the Princesses played with the dogs in the garden and outside their house *Y Bwthyn Bach* (their little Welsh cottage presented on behalf of the people of Wales). A few days later, when the family had returned to their London home at 145 Piccadilly, the photographer Lisa Sheridan came back to take more photographs, including a charming series of the Duke and Duchess of York, the Princesses, and the corgies Dookie and Jane (pages 94-5). These were included in Michael Chance's book *Our Princesses and their dogs*, published in 1936. The dedication – 'To All Children Who Love Dogs' – had been suggested by the Duchess herself.

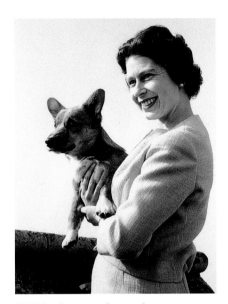

HM The Queen with one of her corgis.

Pages 116–17: Queen Victoria with members of her family, Osborne, August 1898.
Left to right: Prince Leopold of Battenberg; Louise, Princess Aribert of Anhalt; Prince Edward of York; the Duchess of York with Princess Mary; Prince Alexander of Battenberg; Princess Margaret of Connaught; the Duke of York with Prince Albert; Queen Victoria; Prince Arthur of Connaught; the Duchess of Connaught; Princess Patricia of Connaught; Beatrice, Princess Henry of Battenberg; Princess Victoria Eugenie of Battenberg; Princess Helena Victoria of Schleswig-Holstein; Prince Maurice of Battenberg.

Dookie died a few years later at the beginning of the Second World War. Jane was killed by a car in Windsor Great Park in 1944. She had had two puppies on Christmas Eve, 1938: Crackers and Carol. Although Carol had to be put to sleep early on, Crackers lived to be almost 14 years old, dying in the autumn of 1953, by which time he had become a favourite of Queen Elizabeth The Queen Mother.

Jane was succeeded by Susan, who was given to Princess Elizabeth as an eighteenth birthday present in 1944.

In 1952 King George VI died and his daughter Princess Elizabeth ascended the throne as Queen Elizabeth II. All of The Queen's corgis since have been descendants of Susan, whose pedigree name was Hickathrift Pippa. Susan had two puppies in 1949: Sugar remained with The Queen and lived until 1965, while Honey was given to The Queen Mother. Both Susan and Sugar are buried at Sandringham, while Honey, who died in 1956, was buried at Balmoral. Sugar also had two puppies, Whisky and Sherry, given to Prince Charles and Princess Anne respectively as Christmas presents.

While corgis remained the main breed of choice for Princess Elizabeth, other breeds were acquired from time to time. Princess Margaret acquired a Sealyham terrier called Johnny, but shortly after its arrival she became ill and The Queen Mother looked after the dog. After Princess Margaret's recovery, Johnny seemed more at home with The Queen Mother and so she adopted him. Princess Margaret also owned another Sealyham called Pippin, as well as a Cavalier King Charles Spaniel called Rowley and a dachshund (called Pipkin). This was the dog that mated with one of The Queen's corgis, and whose descendants have been named 'dorgis'.

Today The Queen is one of the longest-established breeders of Pembroke corgis in the world. Each dog is registered with the Kennel Club, and shares the bloodline of The Queen's first corgi, Susan. Currently The Queen has nine dogs: five corgis as well as four dorgis. The dogs often travel with The Queen between royal residences and when Her Majesty travels overseas, the dogs are looked after by the wife of the retired head keeper at Windsor.

The Queen continues to be photographed with her corgis, and her love of dogs remains as strong as ever. Her Majesty and The Duke of Edinburgh also continue the breeding programme of gun dogs at Sandringham. It is the corgi, however, like other breeds before it, that has come to represent royalty today in an endearing and enduring way. This royal attachment to dogs continues to be an inspiration to dog lovers everywhere.

Family Tree

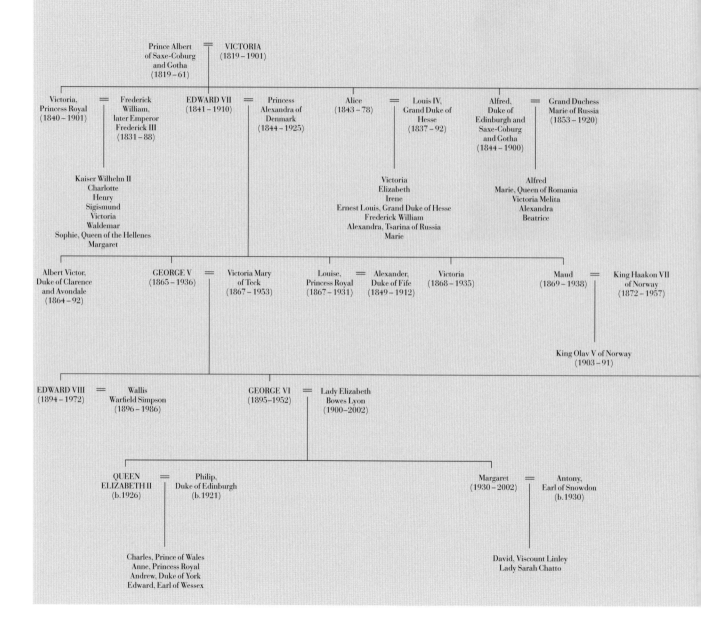

Prince Albert of Saxe-Coburg and Gotha (1819–61) = VICTORIA (1819–1901)

Victoria, Princess Royal (1840–1901) = Frederick William, later Emperor Frederick III (1831–88)

EDWARD VII (1841–1910) = Princess Alexandra of Denmark (1844–1925)

Alice (1843–78) = Louis IV, Grand Duke of Hesse (1837–92)

Alfred, Duke of Edinburgh and Saxe-Coburg and Gotha (1844–1900) = Grand Duchess Marie of Russia (1853–1920)

Kaiser Wilhelm II
Charlotte
Henry
Sigismund
Victoria
Waldemar
Sophie, Queen of the Hellenes
Margaret

Victoria
Elizabeth
Irene
Ernest Louis, Grand Duke of Hesse
Frederick William
Alexandra, Tsarina of Russia
Marie

Alfred
Marie, Queen of Romania
Victoria Melita
Alexandra
Beatrice

Albert Victor, Duke of Clarence and Avondale (1864–92)

GEORGE V (1865–1936) = Victoria Mary of Teck (1867–1953)

Louise, Princess Royal (1867–1931) = Alexander, Duke of Fife (1849–1912)

Victoria (1868–1935)

Maud (1869–1938) = King Haakon VII of Norway (1872–1957)

King Olav V of Norway (1903–91)

EDWARD VIII (1894–1972) = Wallis Warfield Simpson (1896–1986)

GEORGE VI (1895–1952) = Lady Elizabeth Bowes Lyon (1900–2002)

QUEEN ELIZABETH II (b.1926) = Philip, Duke of Edinburgh (b.1921)

Margaret (1930–2002) = Antony, Earl of Snowdon (b.1930)

Charles, Prince of Wales
Anne, Princess Royal
Andrew, Duke of York
Edward, Earl of Wessex

David, Viscount Linley
Lady Sarah Chatto

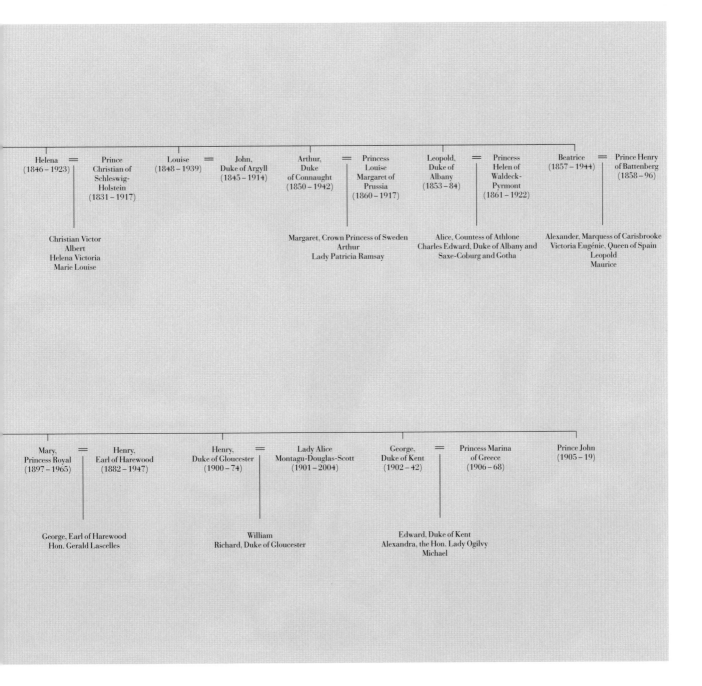

Helena
(1846 – 1923)
=
Prince
Christian of
Schleswig-
Holstein
(1831 – 1917)

Christian Victor
Albert
Helena Victoria
Marie Louise

Louise
(1848 – 1939)
=
John,
Duke of Argyll
(1845 – 1914)

Arthur,
Duke
of Connaught
(1850 – 1942)
=
Princess
Louise
Margaret of
Prussia
(1860 – 1917)

Margaret, Crown Princess of Sweden
Arthur
Lady Patricia Ramsay

Leopold,
Duke of
Albany
(1853 – 84)
=
Princess
Helen of
Waldeck-
Pyrmont
(1861 – 1922)

Alice, Countess of Athlone
Charles Edward, Duke of Albany and
Saxe-Coburg and Gotha

Beatrice
(1857 – 1944)
=
Prince Henry
of Battenberg
(1858 – 96)

Alexander, Marquess of Carisbrooke
Victoria Eugénie, Queen of Spain
Leopold
Maurice

Mary,
Princess Royal
(1897 – 1965)
=
Henry,
Earl of Harewood
(1882 – 1947)

George, Earl of Harewood
Hon. Gerald Lascelles

Henry,
Duke of Gloucester
(1900 – 74)
=
Lady Alice
Montagu-Douglas-Scott
(1901 – 2004)

William
Richard, Duke of Gloucester

George,
Duke of Kent
(1902 – 42)
=
Princess Marina
of Greece
(1906 – 68)

Edward, Duke of Kent
Alexandra, the Hon. Lady Ogilvy
Michael

Prince John
(1905 – 19)

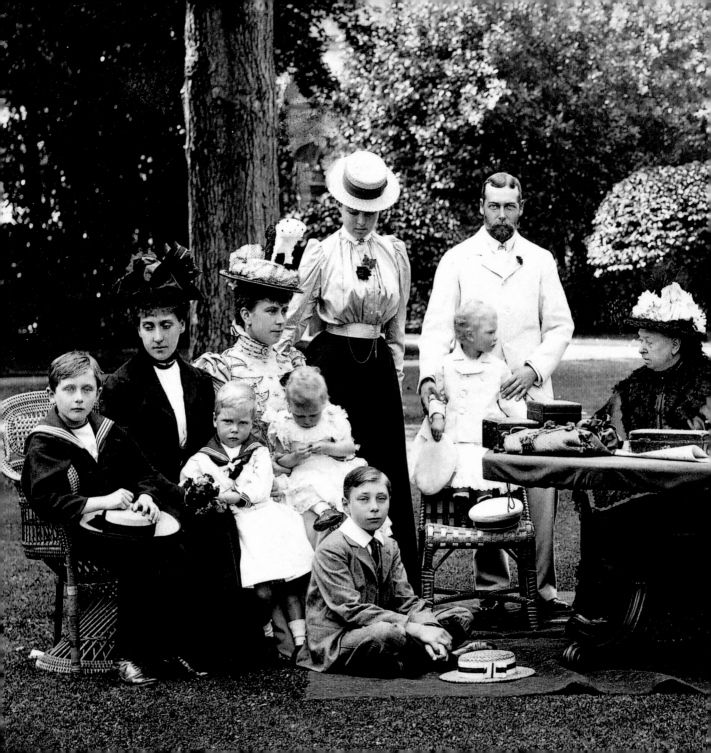

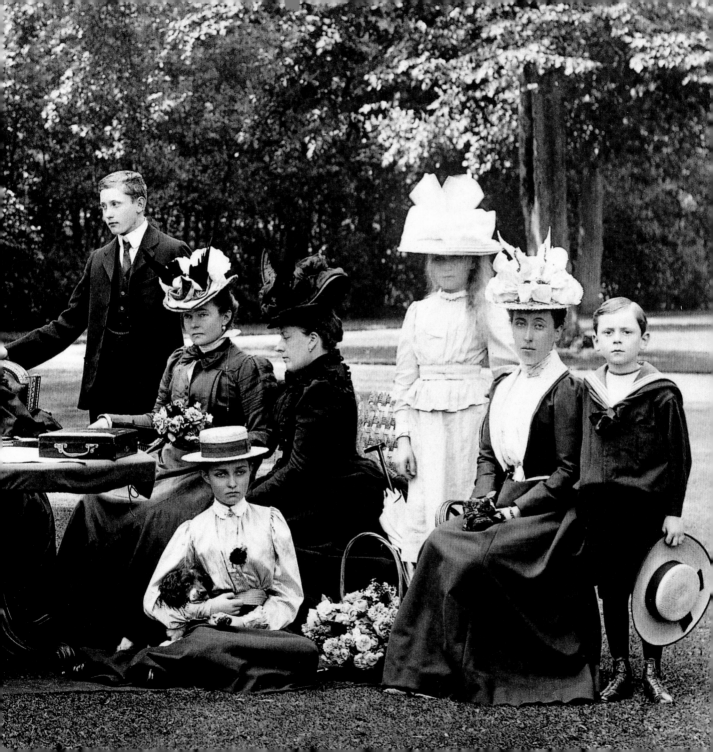

List of Illustrations

List of Illustrations

Index

Index

Acknowledgements

The permission of HM The Queen to reproduce items in the Royal Collection and to consult documents in the Royal Archives is gratefully acknowledged.

The assistance of a number of people and institutions is gratefully acknowledged: Adam Brown, 01.02, for the design; Alison Gardiner; Sharon Butt, Osborne House; Libby Hall; Jenny Knight, copyeditor; Luisa Pontello and the staff of The Kennel Club Art Gallery and Library, and Debbie Wayment. From The Royal Collection and Royal Archives: Julia Bagguley; Angeline Barker; Pamela Clark; Jacky Colliss Harvey; Siân Cooksey; Melanie Edwards; Katharine George; Lisa Heighway; Karen Lawson; Katy Martin; Debbie Bogard; Shruti Patel; Hugh Roberts; Jane Roberts; Paul Stonell; Elaine Ward and Eva Zielinska-Millar.

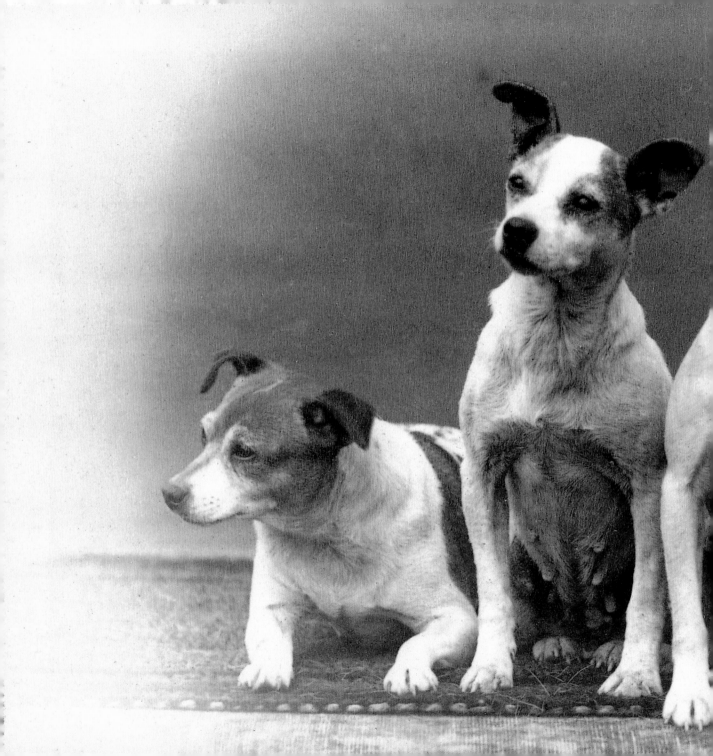